CELTIC ART

DISCOVERING ART

The Life, Times and Work of the World's Greatest Artists

CELTIC ART

O. B. DUANE

BROCKHAMPTON PRESS

For the man who wrote 'An Láir Bhán',
a work which will always move me.

Author's Note:
An amount of crucial background material has been consulted in
order to write this book. I would particularly like to acknowledge the
helpful studies of Ruth and Vincent McGraw, Lloyd and Jennifer
Laing, Timothy O'Neill and Hilary Richardson and John Scarry.

First published in Great Britain by Brockhampton Press,
a member of the Hodder Headline Group,
20 Bloomsbury Street, London WC1B 3QA

ISBN 1 86019 120 7

Produced by Flame Tree Publishing ,
The Long House, Antrobus Road, Chiswick, London W4 5HY
for Brockhampton Press
A Wells/McCreeth/Sullivan Production

Pictures printed courtesy of the Visual Arts Library, London,
and Edimedia, Paris.

Printed and bound by Oriental Press, Dubai

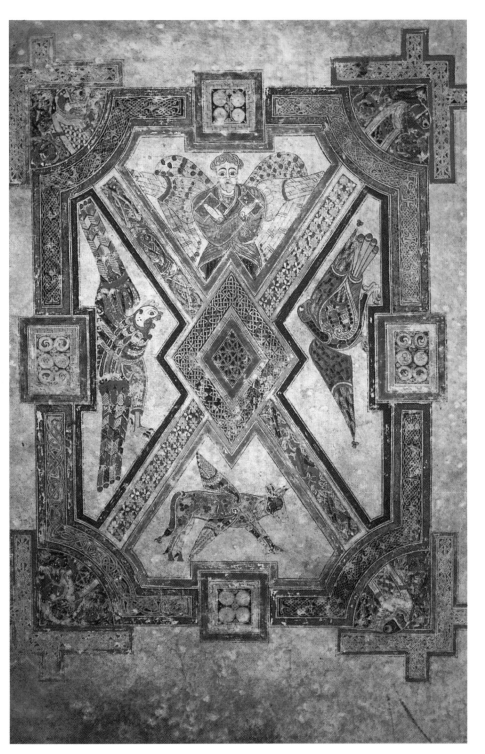

CONTENTS

The Evangelists' symbol pages first
appeared in *Book of Durrow* and the
tradition is repeated a century later in
the *Book of Kells*. This folio reveals the
Evangelist symbol of St John's Gospel
(Dublin, Trinity College).

INTRODUCTION

Celtic Art was not simply a movement. It cannot be dealt with in the same way as Impressionism, for example, or *art nouveau*, where the artists belonged to a prescribed school and followed a set of doctrines.

Celtic Art spans almost seventeen centuries from the early Iron Age to the Anglo-Norman invasion of Ireland in the twelfth century AD. The artistic output over this expanse of time in metalwork, stonework and manuscript work is understandably vast and many changes of style are apparent. This book does not attempt to investigate all areas of Celtic Art and there are necessary gaps in its examination of Celtic craftsmanship. The text concentrates on three main periods, each marking a distinct change of direction for the Celtic artist. The treatment of La Tène culture is followed by an exploration of the early Christian period. The final chapter considers those works created mostly in Ireland when Christianity was well-established and Celtic Art was at its best, though, sadly, approaching decline. The revival of Celtic Art in Ireland in the nineteenth century is a subject demanding far more coverage than this book can provide, but the re-birth of Celticism is an important indication of the value of Celtic civilization to Ireland's artistic heritage.

This book strives to avoid the autonomous language often used in descriptions of Celtic art, but some of the terms may prove unfamiliar to the uninitiated enthusiast. A glossary, explaining these terms, is included at the back of the book.

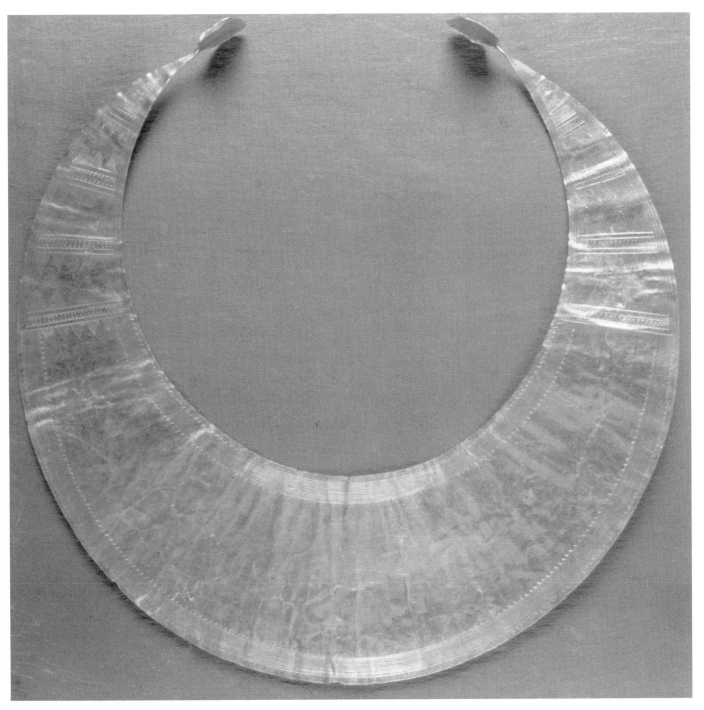

The Bronze Age peoples produced strikingly beautiful ornamental jewellery long before the arrival of the Celts. This gold lunula from Co. Meath is engraved with simple abstract patterns and comes from the early Bronze Age (National Museum of Ireland, Dublin).

CHAPTER 1

Origins of the Celts

The birth of Celtic civilization as we know it has no definitive date. No one particular event encouraged its genesis and the early Celts themselves cannot be described as a geographically unified race.

Overleaf:
Two examples of early Celtic gold rings,
with unsophisticated design
(National Museum of Antiquities,
St Germain-en-Laye).

Opposite:
Carved wooden figure from Ralaghan,
Co. Cavan, Ireland. One of the few full-
length figures in Celtic art. The figure
appears to be male, a detachable penis
was probably inserted into the hole
(National Museum of Ireland, Dublin).

The Celts began life as simple tribesmen, widely scattered across the Alps of northern Europe and along the Upper Danube. They did not belong to a single nation, yet in language, beliefs, customs and rituals, they somehow formed an homogenous group. Ancient Rome and Greece were the first to provide written evidence of the existence of the Celtic people and they provide us with an image of the Celt as a primitive, hairy savage. The Greek word *Keltoi* was used in the sixth century BC to describe a barbaric group of warriors speaking a distinctive language. Historians and archaeologists use the term 'Celt' to describe a loosely knit tribal culture clearly emerging at the beginning of the pre-Roman Iron Age, around 500 BC, and dying out completely towards the end of the twelfth century AD. In modern times, the word 'Celt' is frequently used to describe Irish, Scottish or Welsh peoples with Celtic ancestral blood, some of whom continue to speak a form of the old Celtic language.

The Celts were a nomadic people with a fierce conquering spirit, but they were also imaginative and innovative, displaying an astonishing ability to adapt to new environments. For centuries, they threatened the foundations of Mediterranean society until their power was finally curbed by the Romans, and later the Germanic Saxons, who drove them further and further across western Europe towards virtual extinction. A substantial number of the earliest known Celts appear to have settled in the Middle Rhine region and in north-east France. From here, throughout the fourth century BC, they migrated rapidly south into Italy and east into the Balkans and Asia Minor. Several military victories ensued for the Celtic warriors. The first accurately recorded event involving the Celtic conquerors occurred in 387 BC, when they descended on Rome and defeated its army at the battle of Allia. They expanded further into Greece a century later and conquered Delphi, eventually moving on to terrorize the Hellenistic people of Asia Minor and to establish the kingdom of Galatia there. The conquest of Rome was a major catastrophe for its rulers, introducing the opportunity for many more southern and northern areas of Italy to become infiltrated by the Celts, and it was not until the early third century BC, when their impressive Empire was beginning to take shape, that the Romans managed to undermine the military might of the Celts.

A distinct reversal of power occurred in the year 225 BC, under the Roman general Camillus. Rome finally won a substantial victory over a band of Celts inhabiting the Adriatic coast, and now began to establish colonies all over northern Italy, gradually extending their dominion to other parts of Europe.

By the end of the first century AD, independent Celtic peoples only managed to survive in parts of Scotland, Wales and throughout Ireland. Almost all of their original strongholds were brought under

Roman rule, including the Rhineland and Alpine regions. The Celts had never managed to establish permanent kingdoms in any of the lands they occupied. There was no centrally co-ordinated military strategy and Celtic warriors were not conscious of any sense of political unity. Loyalties remained tribal, rather than imperial. The Roman invasion of Europe ended with the conquest of Britain in the first century AD. The invasion did not extend to Ireland, Scotland and parts of northern England. Celtic peoples and a Celtic way of life were allowed to survive well into the Middle Ages in these territories as a result, while on the Continent, Celtic society became submerged, never to reappear in any significant form.

Our current knowledge of the Celts and Celtic culture in general, owes a great deal to the objects discovered during achaeological excavation and research. Central Europe, in particular, proved to be a rich source of Celtic finds from diverse periods of the long Iron Age. Many of the objects are strictly functional, while others reveal an unmistakable artistic purpose. The art of the early Celts does not readily explore this distinction, however. Early Celtic objects tend to be utilitarian. Pottery, horse-harnesses, everyday drinking vessels and basic iron weapons have all been discovered, but none are of outstanding artistic virtue. Some wood carvings survive, but wooden objects tend to perish easily and these are rare. A few examples also exist of early Celtic stone sculpture, usually of religious significance. There are a few exceptional pieces, however, from the early Iron Age which are truly artistic. Bronze Age craftsmen were especially fond of making jewellery or other personal ornaments and the Celts both inherited and further developed this passion from the early days, well into the Golden Age of the seventh and eighth centuries AD. Some of the best examples of Celtic jewellery were manufactured in Ireland during the eighth century, including the Hunterston and Tara brooches.

Celtic art does not properly emerge until the fifth century BC in Europe. The Celtic period up until AD 500, when Christianity arrived in Britain and Ireland, is known as the La Tène Age. Named after an excavated ancient Celtic settlement in Switzerland, La Tène art is divided into early and late periods. The later period is often referred to as 'ultimate La Tène'. The art is incredibly distinctive in spite of the considerable range of time it covers. The creations of La Tène Celts are eclectic, borrowing heavily from other cultures and artistic repertoires. This was to be the ongoing pattern of Celtic Art. Celtic artists undeniably absorbed Mediterranean influences, they looked to Etruscan art for oriental and mythological symbols, including lotusbuds or blossoms; they borrowed extensively from the Romans and made use later of many Christian symbols, including the sign of the cross. They imitated Greek designs, copied decorative patterns from

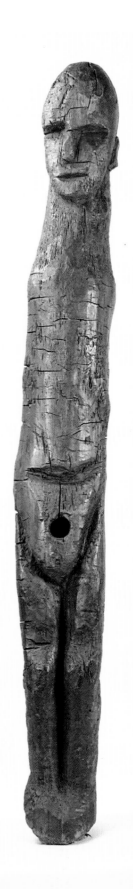

the Scythians in the Russian Steppes, and also appropriated Anglo-Saxon designs. Each foreign idea was adapted and modified to produce spectacularly unique works of art.

Celtic art is characterized by a simple balance of abstract patterns, refusing all attempts to mimic an immediate natural or animal environment. It is decidedly non-representational, providing a complete contrast to the classical Greek or Roman approach to art. Human forms, for example, appear only very occasionally. There are very few full-length human representations in early Celtic art and virtually no female figures. The human head is known to have been venerated by the Celts and many heads appear in stone work, especially in the early Pagan period, in the form of deities once worshipped by the Celts. The faces of the gods are always stylized, their features often grotesquely distorted. Very few human images appear in metalwork and when they do appear they are buried in elusive foliage patterns.

Metalwork was a specialized skill of the Celtic craftsmen and the roots of Celtic art are best traced in metal objects. The artists used combinations of iron, bronze, gold and also silver in the many objects they produced, both secular and religious. From the earliest times, the Celts displayed a love of ornamentation and their art is dominated by spiral patterns, curvilinear designs, foliage motifs, plant tendrils, scrolls, trumpet scrolls, zig-zags, loops, simple geometric shapes, palmettes and triskeles. They were also fond of using compasses to produce symmetrical designs. A renowned Celtic scholar, P. Jacobsthal provides an incisive description of the Celtic artist's achievements in his book *Early Celtic Art*:

> ... *their art is full of contrasts. It is attractive and repellent; it is far from primitiveness and simplicity; it is refined in thought and technique, elaborate and clever, full of paradoxes, restless, puzzlingly ambiguous; rational and irrational; dark and uncanny – far from the loveable humanity and transparency of Greek art. Yet it is a real style, the first great contribution by the Barbarians to European art, the first great chapter in the everlasting contacts of southern, northern and eastern forces in the life of Europe.*

Later Celtic art introduced more lavish decorative elements and materials, including enamelling and *millefiori* glass (introduced by the Romans), coral insets, gold filigree patterning, complex interlacing and more vibrant colours through the use of imported pigments. Simple geometric designs were eventually superseded by the introduction of animal images and those of birds, fish and reptiles. After the arrival of Christianity in the British Isles in the fifth century, human forms were merged with vegetal patterns and appear prominently and

magnificently in the brand-new medium of manuscript illumination of the various monasteries. This later art form drew on all the decorative and ornamental back-catalogue of Celtic metalworkers. Many consider the illuminated manuscripts to be the greatest surviving treasures of Celtic artistic tradition.

The outstanding level of craftsmanship achieved by the end of the Christian era is demonstrated most spectacularly in the *Book of Kells*.

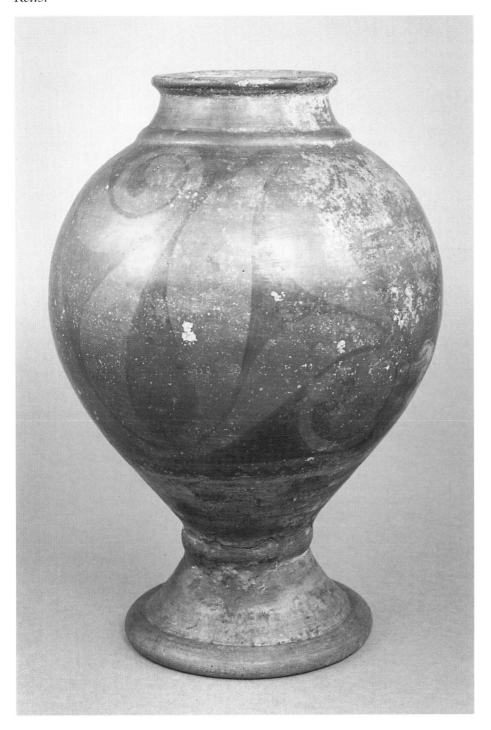

An example of an early Celtic terracotta pottery urn with curvilinear designs, discovered in Britain and probably dating from the third century BC (British Museum, London).

CHAPTER 2

La Tène Art

La Tène art first appeared on the Continent in the fifth century BC. The La Tène Celts were essentially agriculturists, organized into small tribes presided over by Celtic chieftains.

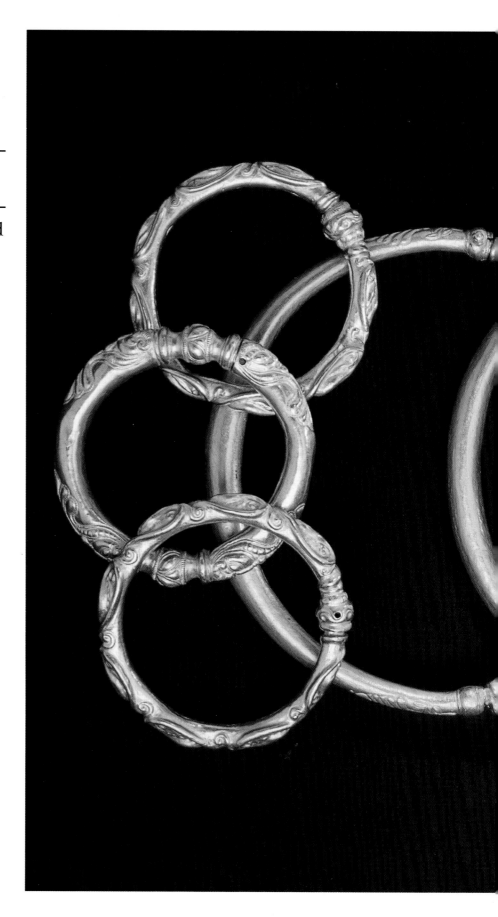

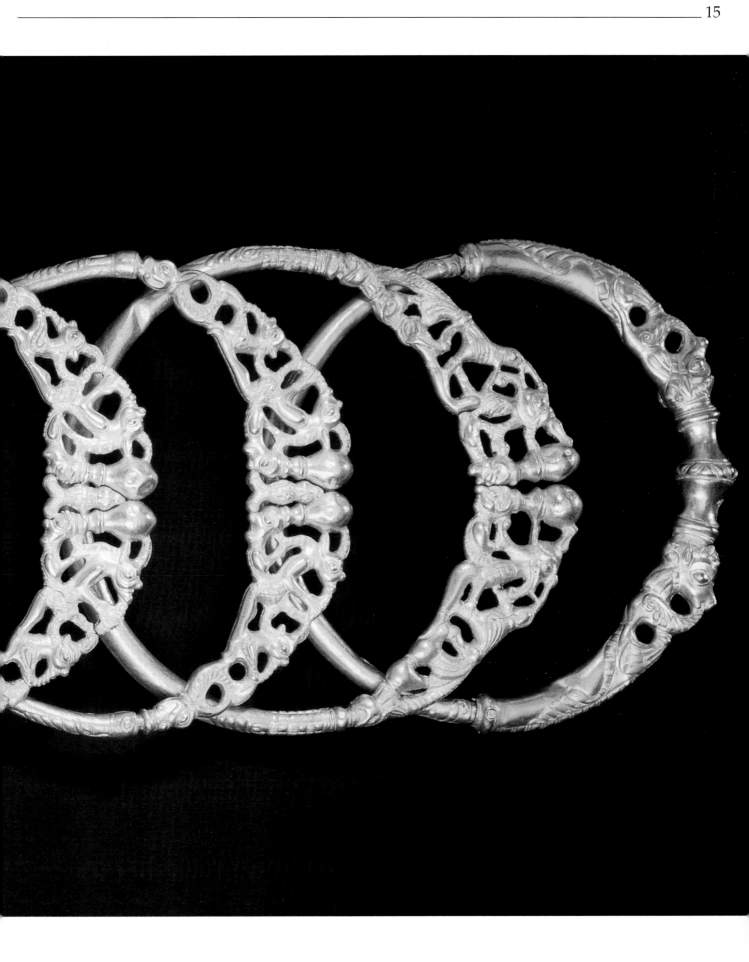

eltic culture cannot be distinctly recognized before the fifth century, although some art historians argue that the Hallstatt culture which came before it was similar in many respects. The Hallstatt period, from the eighth to the fifth century BC, derives its name from a pre-historic salt-mining site and its associated burial plots in western Austria. Objects excavated from these graves share many of the characteristics of early Celtic Art and no doubt strongly influenced its orientation. Hallstatt culture favoured a new practice of cremating the dead, thus allowing easy identification of burial sites throughout Europe. The graves provide a good indication of the geographical expansion of these tribes. Hallstatt culture seems to have emerged to the east of central Europe; it is here that the earliest objects have been discovered.

From the seventh century BC onwards, it extended into Czechoslovakia and Bavaria and finally spread northwards into the Rhineland regions of Germany. The Hallstatt settlers were highly skilled in metalwork, most of which was produced from bronze. Towards the end of their existence, however, they were introduced to iron. Because the new metal was much harder than bronze, it proved highly popular and was employed in the manufacture of weapons and battle paraphernalia.

Trade links were established early on between Hallstatt peoples and classical cultures of the Mediterranean. Many goods were imported from the Greeks and the Etruscans, including luxury bronze drinking vessels and bronze tableware which served as models in the creation of their own art. The Vix *Krater* was discovered in the grave of a princess in the Côte d'Azur, France, and dates from the late Hallstatt period. It is undoubtedly an import from Greece. There is distinct Greek lettering on the sides of the bowl, providing instructions for assembly. The vessel is an extremely large piece, over six feet tall, and it was probably intended for the mixing of wine or beer. It is decorated with processional foot soldiers and chariot drivers carved in low relief bronze.

Hallstatt artists were also fond of animal representations in their metalwork. Bronzes of stylized bulls, cows and other animals vital to their agricultural lifestyle, are plentiful. The most famous of these is the bull discovered in a cave in Blansko, Czechoslovakia. This sixth-century piece is highly accomplished and some believe it was an import from the classical world. The round staring eyes, now empty, were probably originally inlaid with iron. Riders on horseback adorn other metal objects, and birds, particularly waterfowl such as swans and ducks, appear on much of the art. Wheeled vehicles became more common with the introduction of iron. Bronze castings of wheeled chariots were often placed in burial sites, together with bronze armour and horse-gear, iron axes and weapons.

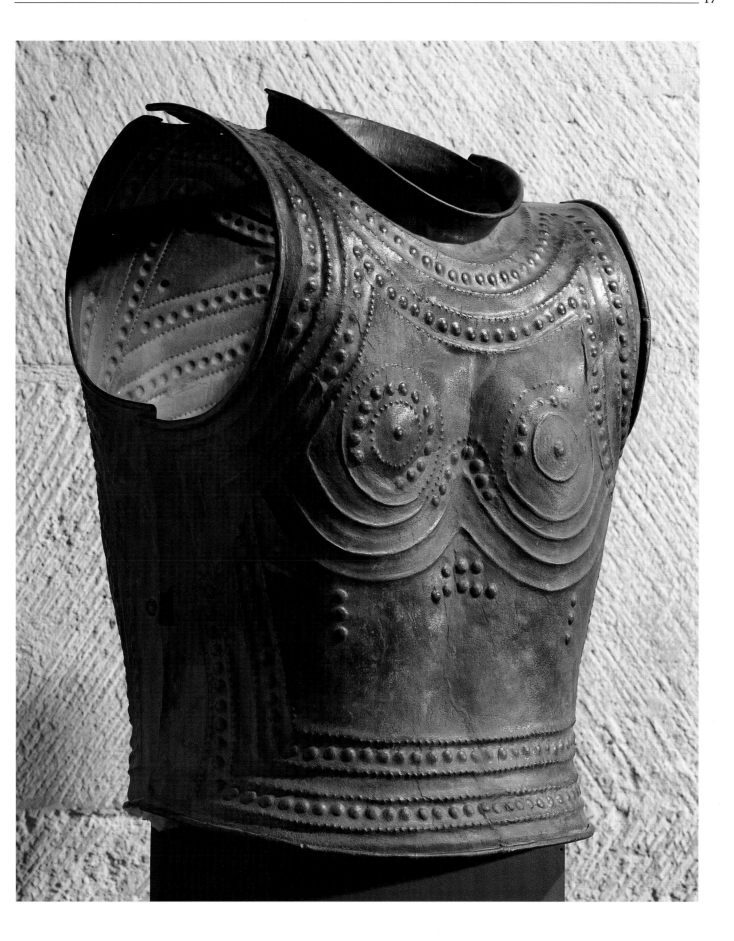

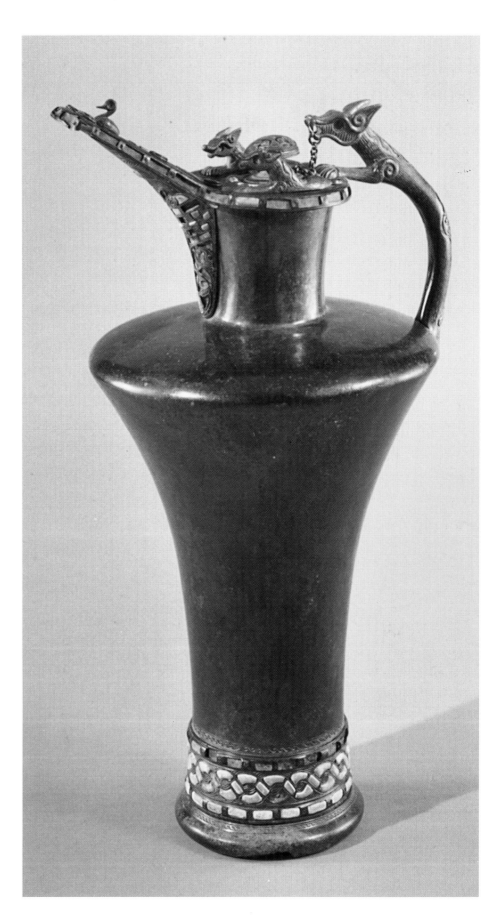

One of a pair of bronze flagons
discovered in France, dating from the
fourth century BC (British Museum,
London).

This bronze chariot mount with classical vegetal openwork decoration, was discovered in a warrior grave known as La Bouvandeau, in Somme-Tourbe, France. It dates from the late fifth century BC (British Museum, London).

Celtic civilization, once it emerged, did not have to seek out too many new sources of inspiration. Hallstatt art made liberal use of classical and oriental elements, including palmettes and floral geometric designs, but the Celts, unlike the Hallstatts, were intent on modifying what they saw. The transformation of Greek or Italic motifs into a non-naturalistic art form signalled the dawn of the La Tène Celtic style.

Rich graves are a particular feature of the early La Tène period, particularly those in more northern areas of Europe, from the middle Rhine, deep into the heart of France. Major excavation work began on a site on the banks of Lake Neuchâtel in Switzerland in 1874. The description La Tène came into use following the enormous amount of material recovered here, dating from the early Celtic period. The first archaeologists to discover these vast hoards of Celtic treasure were convinced that barbarian tribes were incapable of such fine creations and attributed many of the objects to Etruscan craftsmen. We now know that this assumption is false and that the Celts were highly proficient in many areas of artistic expression. Celtic tribes of the early Iron Age did not cremate their dead and the most important possessions of the deceased accompanied them to the burial chamber, similar to the Ancient Egyptian custom. Many exquisite gold objects date from this period of inhumation. With the exception of a few finds located in rivers or marshlands, hardly any objects of quality are found outside of the burial sites. Items which have been discovered consist mainly of pottery or plain drinking flagons used in normal, everyday life.

Many of the extraordinary drinking vessels found in the early La Tène graves attest to the ongoing import of wine from the Mediterranean. Celtic civilization appears to have expanded through trading

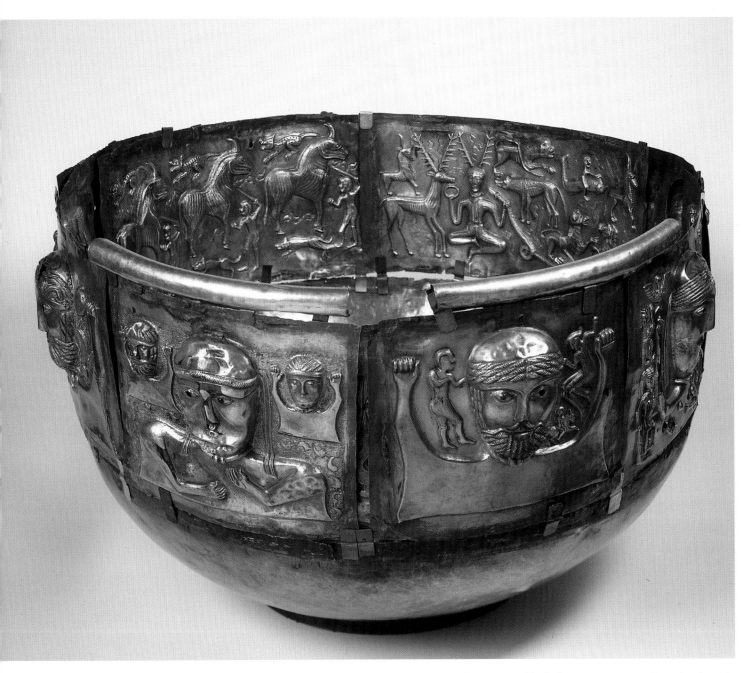

Gundestrup cauldron: The origins of this piece are still in doubt. It displays a good deal of Celtic iconography, but the style suggests a non-Celtic source of manufacture (National Museum, Copenhagen).

links, until eventually the Celts controlled the routes previously dominated by Greek or Italic races. They evidently treasured wine flagons which had come from Greece. In time, they began to create their own version of these vessels. Visual impact triumphed over naturalistic design and within a short period of about fifty years the concept of visual expression had matured dramatically, far removed from nature and classical ideals of beauty.

The most elegant Celtic flagons from this period were discovered in Basse-Yutz in the Moselle region of the Middle Rhine. They were found by a group of railway workers in 1927. Now kept in the British Museum, they are thought to belong to the fourth century BC when

Celts had started to develop their own distinctive style of art. Designs which were passed on through contact with the more developed civilizations of the Mediterranean have been absorbed and revitalized to produce these splendid vessels. At a very early stage, the Celtic artists displayed a love of infill and delighted in ornamental detail. The bodies of the bronze flagons are left plain, but the bases and spouts are decorated with enamel and coral insets. The lavish use of red Mediterranean coral is unparalleled in any other work of this kind. Coral is used far less elaborately on early brooches, scabbards and neck ornaments. The handles of the flagons are dog-shaped; a chain attaches the jaws of these animals to the lids of the flagons. Human faces, combined with palmette designs, appear on the base of the handles. These faces display a Celtic love of ambiguity, or transformation; they can be 'read' or interpreted in a variety of ways. Shapes, for example,

The Amfreville helmet is an excellent example of the Waldalgesheim style. It dates from the late fourth century BC (Reunion des Musées Nationaux, Paris).

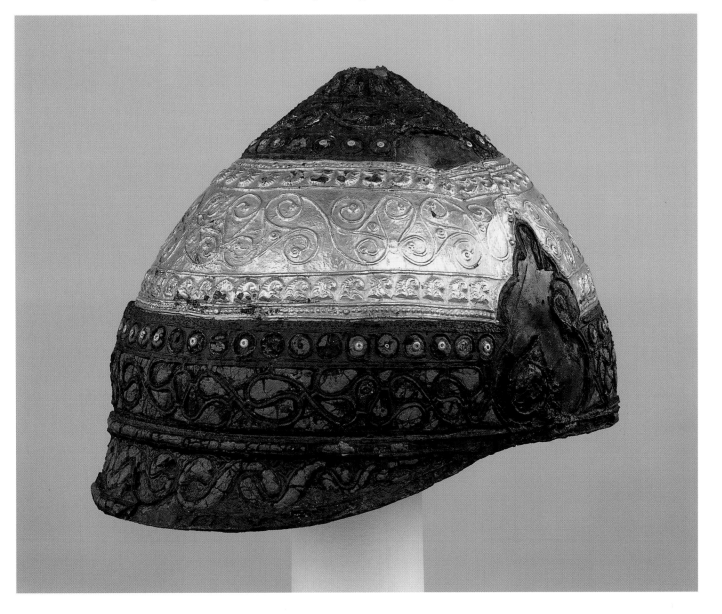

An early example of Celtic gold
jewellery discovered in France
(National Museum of Antiquities,
St Germain-en-Laye).

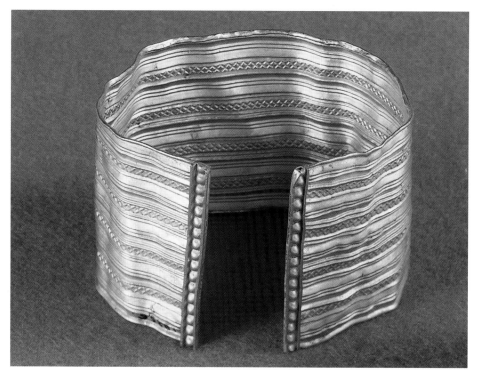

Opposite:
Figure carved on limestone pillar, with
damaged facial features and torque
around the neck. Discovered in Haute-
Marne, France, circa first century BC
(National Museum of Antiquities,
St Germain-en-Laye).

which may appear abstract from one angle can become faces when
viewed from another. If reversed, the faces on the Basse-Yutz vessels
show quite a different expression. A tiny duck rests on the spout of
each flagon, carved in high relief. The flagons display Celtic adaptation
of previous forms. They are more concave and ornate, for example,
than their rounded Italian prototypes.

The Rhineland areas have delivered many of the richest treasures
of the early La Tène era. Craftsmen here appear to have been more
innovative and certainly wealthier as a result of increasingly advanced
trade routes to the rest of Europe. Sheet goldwork was a particular
feature of this region. The Celtic artist decorated his personal
ornaments to a high degree of perfection. A whole series of superb
gold neck rings and bracelets have been discovered in areas of the
Middle Rhine. The burial chamber of a princess at Reinheim, circa mid
fourth century BC, was excavated in 1956, to reveal over two hundred
items of jewellery, including gold and iron brooches, intricate glass
beads, bronze mirrors, finger rings, arm rings, bronze basins and gold
drinking-horn mounts.

The famous Erstfeld gold treasures were discovered on the route
to Italy in the southern Swiss valley of Erstfeld. They are too similar
to other Rhineland pieces to be of Italian origin and it is possible they
were abandoned by a looter intending to return to his cache. The four
striking neck rings and three gold rings were accidentally discovered
by builders in 1962. The jewellery represents an exceptionally high
standard of Celtic workmanship in gold and it was probably all
created by the same goldsmith. A great many images in Celtic art

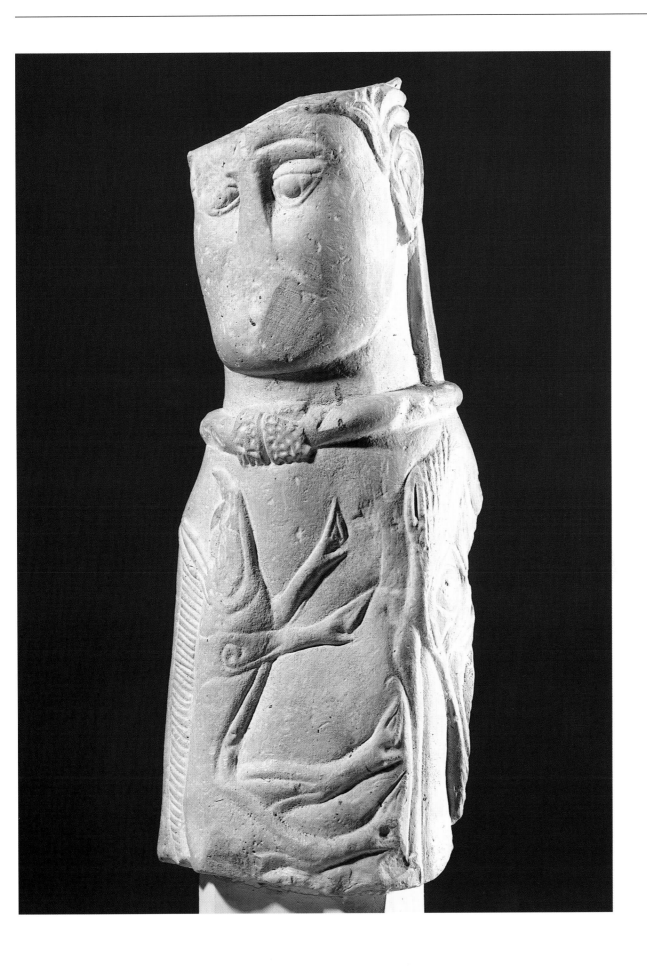

continue to defy explanation and the imagery on the Erstfeld collection is mythological and strange. Plants, horned beasts, stylized human figures, birds and monsters intermingle in the engraved designs to produce an obscure effect, characteristic of the developing Celtic style.

The Waldalgesheim princess's burial site in Germany has revealed a series of objects marking a decisive new development in Celtic art. It was at this time that the Celts embarked upon their most intense period of expansion southwards and eastwards into Europe. A northern Italian influence is very apparent and led to what is known as the vegetal style. In the fourth century, as discussed earlier, the Celts invaded Rome, followed by Greece and the Balkans. Human forms and animal images faded into the background of their art to be replaced by classical plant motifs in a variety of forms, including palm fronds and lotus-buds. The emergence of this foliage pattern and the strong Italic influence is clearly evident in a number of ceremonial helmets of this period, in particular, the Amfreville helmet. The bronze cap-shaped helmet is decorated with gold *repoussé* foliage-patterned sheets, inlaid with iron and enamel.

Cauldrons had a special place in early Celtic civilization. These large pots were probably produced for ritual purposes and were believed to have regenerative powers. The Gundestrup cauldron was discovered in 1891 in a Danish peat bog, although it is not Danish in origin. Dating from the late second century or early first century BC, it is most likely to have been made in Eastern Europe, probably in eastern Hungary, Romania, or even Bulgaria. The cauldron was deliberately dismantled for burial and only some pieces survive. It is made of silver gilt plates, probably manufactured by several hands. The artist who produced the highly complex iconography on the plates is not the same artist who decorated the basal disc of the cauldron.

Many of the designs and depictions are clearly Celtic. Shield bosses, torques, cap-shaped helmets, images of boars, sacrificial bulls and birds of prey are all derived from the Celtic repertoire. Other designs are alien to the art of the Celts, however, they include the ivy-leaf patterns and horizontal lines scored on the clothing of the warriors going into battle. The imagery is also incredibly enigmatic and much of it appears to be quite new. On the disc base a bull lies slain, a lizard rests close to his hooves. Above the bull a figure lunges at a dog with a sword. A cross-legged god with antlers appears on one of the plates. He holds a torque in his right hand and a curling snake in his left. To the right of this figure, a young boy is shown riding a dolphin, pursued by a boar snapping at his heels. Various quadrupeds with gaping jaws and protruding eyes occupy the remainder of this beaten silver plate. The Gundestrup cauldron was probably made in the late second century BC. A second cauldron, the Rynkeby cauldron, also discovered

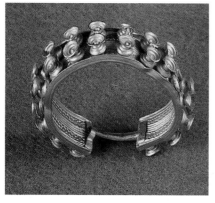

Detail of early Celtic gold jewellery, unearthed in the French countryside (National Museum of Antiquities, St Germain-en-Laye).

in Denmark, is a far less sophisticated bronze version, of which only fragments have survived.

Celtic coins are often works of art in themselves and a great many have survived, frequently in huge hoards of up to ten thousand, which may have been offered up to the gods or simply collected together as some form of status symbol. The Greeks were the first to produce coins in the seventh century BC and the Celts followed their example towards the end of the fourth century BC. The very first Celtic coins were made of gold and were direct copies of the Greek variety. Eventually they were made of silver or bronze. Early coins relied on classical images and were not of any original quality. The Celts gradually introduced their own motifs into the field of coinage. The subject matter was largely confined to plant life to begin with, but gradually animal symbols began to appear. The reverse side of the coin, which had been dominated previously by an image of Apollo, was eventually replaced by that of the Celtic chief. Subjects were never over-simplified and the artist showed tremendous skill in engraving. Celtic coins were far from technically perfect and differed from Roman and Greek coins in this respect. The Celtic artist, at all times and in all fields, seemed more pre-occupied with the expression of his emotions.

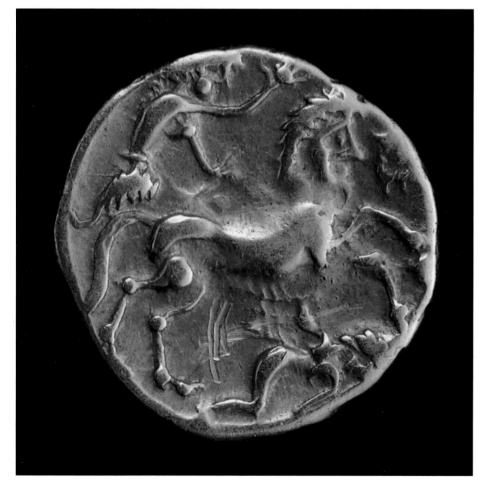

Second-century Celtic gold coin. The outline is always irregular and the animal imagery, especially that of horses, is a typical feature (British Museum, London).

Sheet bronze figure with torque showing the Roman influence of more naturalistic representation (National Museum of Antiquities, St Germain-en-Laye).

By the end of the second century BC, local Celtic coins were being used in at least six regions of La Tène Europe. The richest collection of Celtic coins in Europe, over 15,000 examples, is housed in the Bibliothèque Nationale in Paris.

La Tène sculpture survives in stone, bronze and, to a lesser degree, in wood. One of the best-known early Celtic wood carvings was discovered in Source-de-la-Seine in France. Often fondly described as the 'duffel coat' figure, this sculpture, dating from the first century, was part of a group showing little sign of classical influence. The human-like creature depicted has an unusually large head and no arms. The limestone pillar statue from Euffigneix, less than a foot tall, and dating from the first century BC, is a very fine miniature example of what is known as Gallo-Roman stonework. Together with the sheet bronze statue from Bournay, France, this figure shows the increasing influence of the Romans on early La Tène art, moving towards realism and the Ultimate La Tène period. The bronze Bournay statue belongs to the last days of Celtic sovereignty, before the Romans seized power. The torso of the figure, probably a divinity, is realistically modelled, but the lower half is foreshortened and ends at the waistline with a pair of truncated legs. The foliage pattern of the hair is unusually Roman in its design.

The description 'insular' La Tène art may be applied to the art of Britain and Ireland from the fifth or fourth century BC until the Roman invasion in the first century BC. The migration of the Celts to Britain and Ireland from the third century BC onwards is discussed in more detail in the next two chapters. La Tène culture died a lingering death in Europe with the spread of Roman civilization. In Britain, an Ultimate La Tène art, heavily influenced by Roman ideas, managed to survive for a limited period. The Celts in Britain seemed to adapt well to their Roman rulers for a time and a new Roman-inspired Celtic art flourished until the Anglo-Saxon invasions. Truly 'insular' Celtic art existed only beyond the Roman frontiers. With the coming of Christianity this art changed character once again. La Tène art of the Iron Age gave way to new influences and elements. A whole new revival of Celtic Art was about to begin.

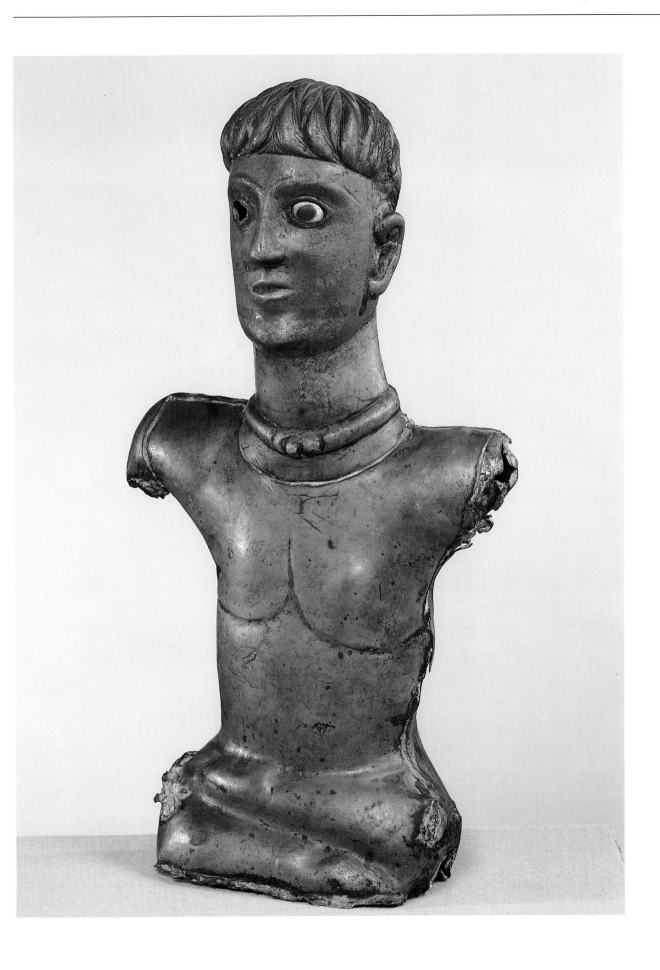

CHAPTER 3

The Early Christian Period

For some people, the term 'Celtic art' promotes an immediate image of Ireland, and the art produced in that land by Celtic civilizations at a time when the seeds of Christianity had just begun to flourish.

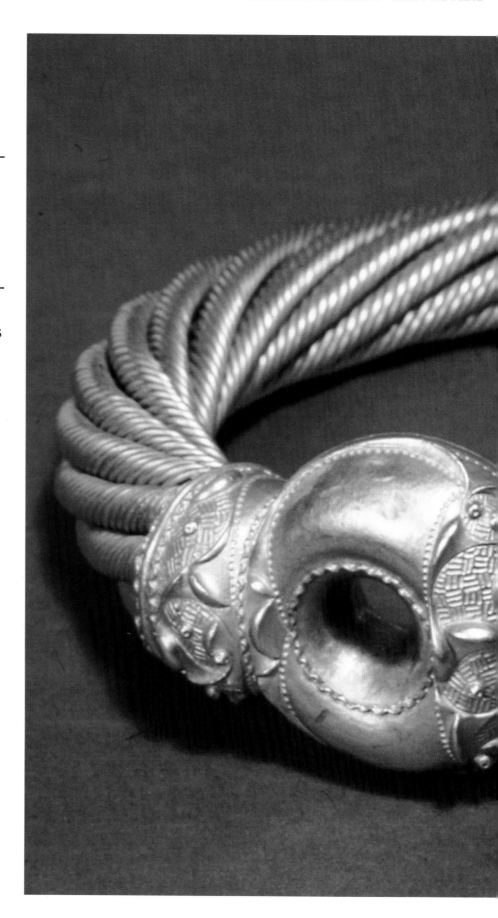

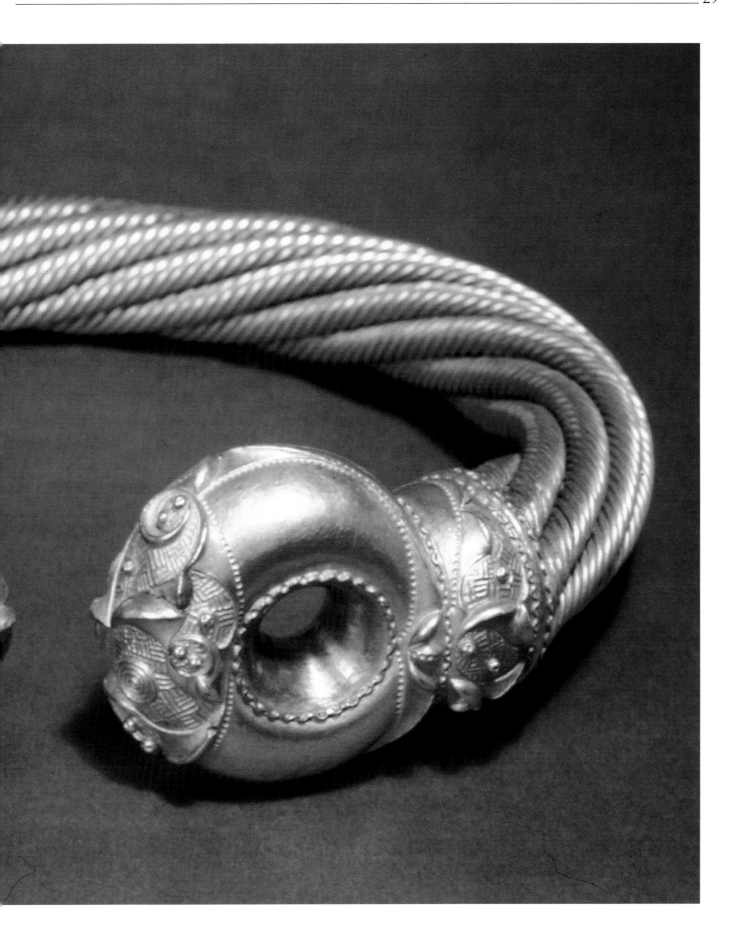

Overleaf:
Gold torque found in Norfolk. It was
part of a hoard of six torques dating
from the first century AD
(British Museum, London).

The foundations of Celtic art have already been discussed and its much broader continental origins explored. It is, of course, true to say that Ireland fostered what might be termed a 'renaissance' in Celtic art, as a result of the Christian movement, but Ireland was already Celtic in social structure and traditions long before the spread of Christianity. The earliest Celtic immigrants to the British Isles may have arrived as early as the late Bronze Age, in the sixth century BC. It is certain, however, that Celtic society within Europe began to expand in earnest during the Iron Age, around the fifth century BC. Over the centuries, Celts migrated east and then west until eventually their military power was eclipsed by the Romans. The increasing dominance of Rome pushed Celtic tribes into Western Europe.

Trading between the British Isles and Europe was already well established by the third century BC. Many items of fine metalwork were imported in the Late Bronze Age along the east coast of England, thus introducing a whole new range of artistic influences.

Britain and Ireland were the last to experience Celtic penetration, but the influence of Celtic civilization spread remarkably quickly once it had arrived. A distinctively insular style of Celtic art is apparent in Britain by the third century BC. Although influenced by European La Tène culture, local variations in design and treatment are unmistakable. Within a short space of time, craft centres were set up, among them the East Anglian school of gold-working, producing native designs of outstanding quality and workmanship. From this insular period, Britain produced a series of stunningly engraved bronze mirrors whose large, circular open areas allowed for the most intricate decoration, unparalleled by European example. It is certain that the Celts were firmly established across the ocean in Ireland during the Iron Age, which began around 500 BC. The great stone fort known as Dun Aengus, situated on a cliff-edge on the Aran island of Inishmore, is an early example of the presence of Celtic barbarians, described by the Irish as *Fir Bholg*.

First examples of continental La Tène art appear to have arrived in Ireland by the third century BC. Excavations have uncovered a number of La Tène golden torques, sword scabbards and also war trumpets favouring the curvilinear Celtic style. One of the earliest torques was discovered in a peat bog at Clonmacnoise and may well have been imported from the Rhineland. The country's most famous example of late La Tène art is the magnificent Broighter collar, discovered in Co. Derry, along with several other objects of personal ornament. It is made of gold and is decorated with La Tène style foliage patterns in *repoussé*, against an intricately engraved background.

Ireland too developed its own insular style of Celtic art with confidence and flair. Archaeological evidence indicates an armoury at Lisnacrogher, Co. Antrim, which produced some outstanding early

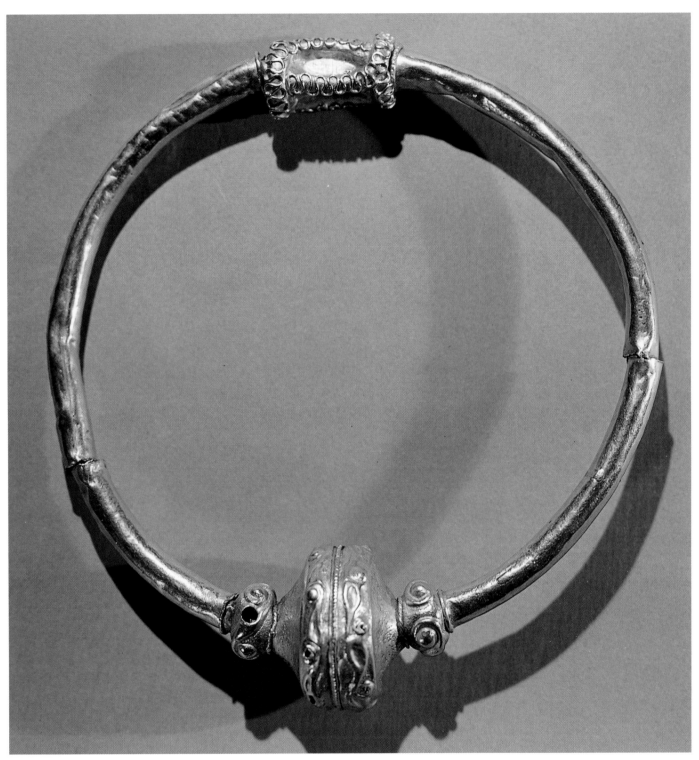

metalwork. Continental influences, particularly similar to the objects found in the Waldalgesheim grave, are apparent in vegetal designs, S-scrolls and wave-tendrils, but these motifs eventually receive more elaborate, individual treatment. Elegant bridle-bits and dress-fasteners cast in bronze have been discovered, embellished with enamel and intricately engraved. Celtic weapons, horse-trappings and other

The Clonmacnoise torque was discovered in the third century BC. Plant-based spirals decorate the neck ornament, thought to have come from the Middle Rhine region of Germany (National Museum of Ireland, Dublin).

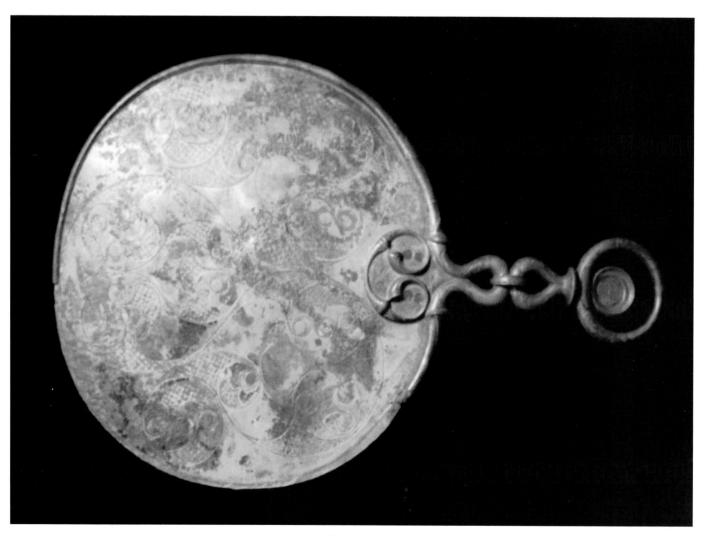

The designs on these great mirrors were produced using a compass. Large areas were filled with basketry ornament in an array of colours. Most were produced from the first century BC to the first century AD (Gloucester Museum, UK).

personal jewellery also survive in both bronze and gold; the art is abstract and highly stylized.

By the middle of the first century AD, most of the original Celtic lands had fallen under Roman rule. The kingdom of Gaul, once a monumental landmark of Celtic civilization, had fallen to Julius Caesar by the middle of the last century BC. From about this time, the creative output of the European Celts diminished considerably. The conquest of Britain under the Roman Emperor Claudius was well under way by the year AD 40. By the third century AD, Celtic art had all but disappeared on the Continent and was increasingly subjected to a powerful Roman influence in England. Ireland and the north of England, on the other hand, remained outside of the Empire and were to offer new breeding grounds for Celtic art, culminating in many of the great popular masterpieces most readily associated with the Celtic movement today.

The Roman influence on Celtic art in Britain and, to a lesser extent, Ireland deserves a mention here. Ireland's close proximity to Britain meant that it too experienced some of the changes in artistic style

precipitated by the Romans during this period, although, in essence, Ireland was to remain far more insular. The Roman impact on Celtic art in England was not so instantaneous or divergent as some have imagined. Many art historians argue that Rome introduced not so much a cultural break, but rather a healthy new development of existing artistic traditions. Britain certainly grew more wealthy as a result of trade across the North Sea and it benefited from Roman technological advances; for example, the use of red enamel was an important innovation introduced by the Romans. Craftsmen also began to experiment with silver, and *millefiori* glass came into use at this time. This technique involved fusing narrow rods together, drawing them out and then slicing them. The thin patterned slices were then usually set in red enamel. It has been suggested that the cloak and tunic, a Mediterranean form of dress, was introduced to Britain by Rome and with it, the early penannular pins or brooches with their fashion for miniature metalworking.

Art took on a new, openly official significance under the Romans and much that has survived from Roman Britain is functional, including a great deal of horse-ornaments, casket mounts, items which show a symmetrical design alien to the La Tène tradition, yet appealing to the Romans. Roman 'hanging bowls' are the exception to this utilitarian focus and represent the last great flowering of Celtic art in Britain. Some ninety hanging bowls survive, many discovered in later Saxon graves, but clearly of Roman origin. The earliest examples were made of bronze and decorated with red, yellow and blue enamel and also *millefiori* glass. Floral patterns, peltas (the Mediterranean version of the early Celtic palmette), and bird-headed spirals adorn the bowls. Many of the patterns on these objects were later used, in a more perfected form, in manuscript illumination.

The most significant change in Celtic art which may be attributed to the Romans was the introduction of Christianity. The Christian faith was widespread in Britain by the fourth century, gradually extending into parts of north and south Wales and southern Scotland, as far as Hadrian's Wall. By the time Ireland was Christianized in the early fifth century, the Romans in Britain were already retreating and a new Germanic Saxon race had begun to conquer the territories of Britons. Ireland flourished as the stronghold of Christian belief, while Britain progressively surrendered to the pagan practices of the new Anglo-Saxon invaders. From its earliest advent in Ireland, Christianity followed a different pattern of development to Roman Britain. Because Ireland had never been invaded by the Romans, it had maintained a more traditional social structure. Britain had become urbanized by Rome and a diocesan Church structure had been introduced. Celtic society in Ireland was more rural and tribal; there were no cities and no real towns worth speaking of. An

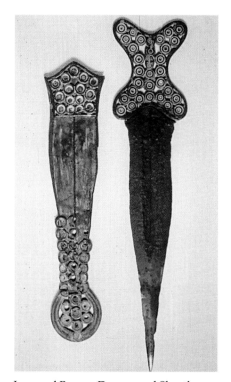

Iron and Bronze Dagger and Sheath – found in the River Thames. These objects represent early examples of Celtic influence on British art. They are difficult to date, but it is almost certain that they were made some time between the end of the Bronze Age and the beginning of the Iron Age (sixth to third century BC) (British Museum, London).

The designs on this first-century AD collar, discovered in County Derry are very obviously La Tène in style. It is plausible that the most significant wave of Celtic migrants arrived in Ireland at this later period of the Iron Age (National Museum, Dublin).

altogether different monastic system of Christianity sprang up as a result. Irish art and craftsmanship had been allowed to develop independently. The Irish artist had absorbed certain Roman influences, but he had used them to create something original, something unique. The fusion of Christianity and the self-reliant artistic vision of the Celts in Ireland produced an incredible result almost impossible to achieve in neighbouring Britain. The building of monasteries, the making of manuscripts and chalices for altar use, and the carving of Christian images in stone all mark the beginning of a new phase, the Golden Age of Irish art, when Celtic craftsmen in Ireland developed their skills to perfection.

By the year AD 431, Pope Celestine I of Rome had sent his first bishop, Palladius, to Ireland, which indicates that the Christian faith must have been fairly well established by this time. The traditional date for the arrival of St Patrick in Ireland is 432 and he is credited,

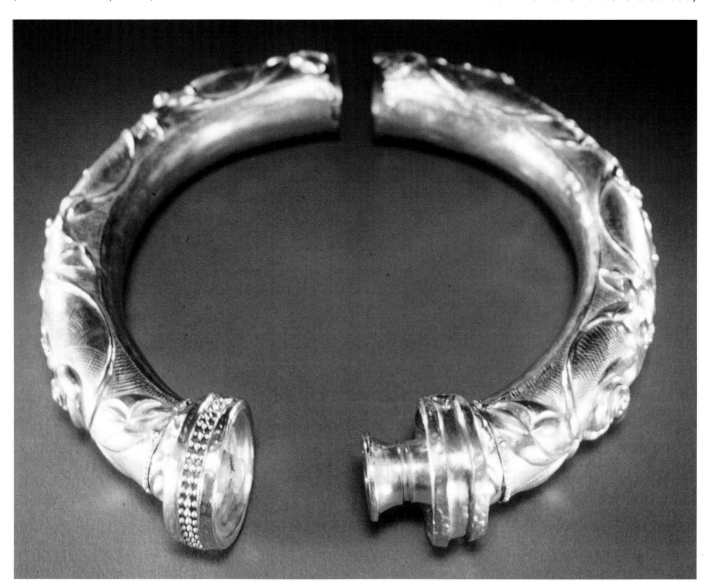

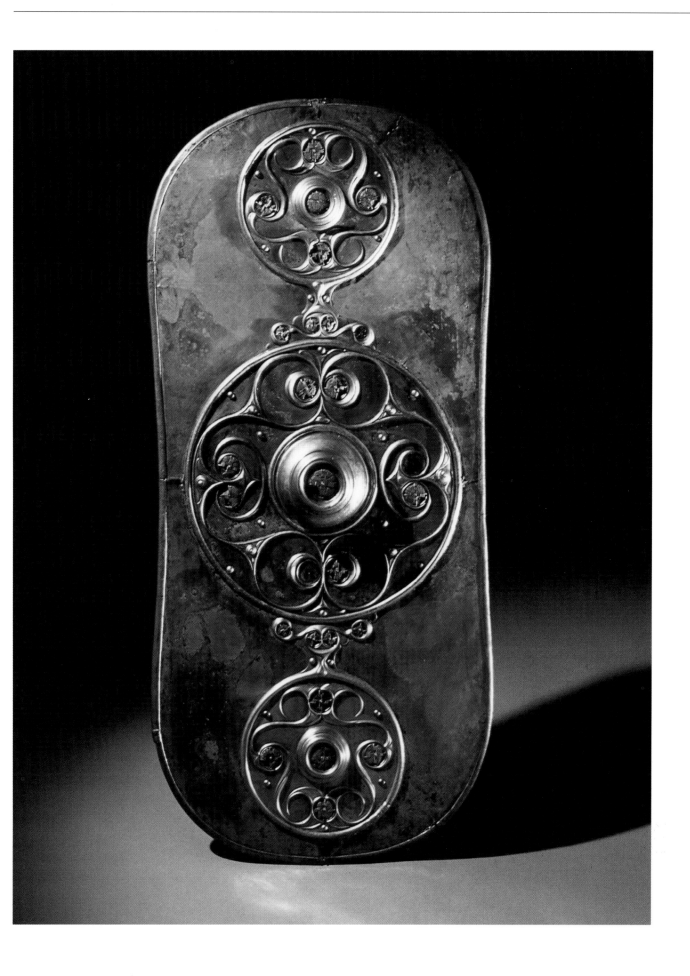

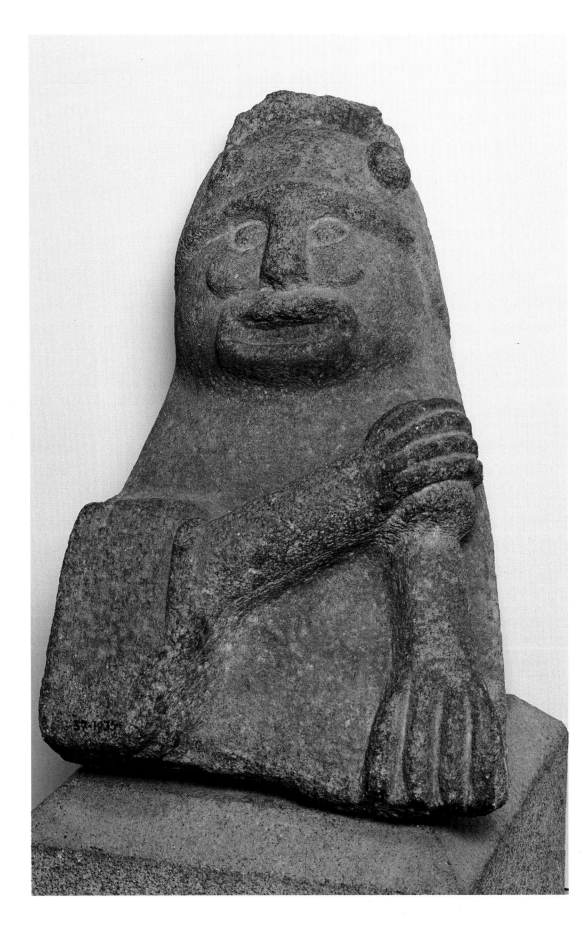

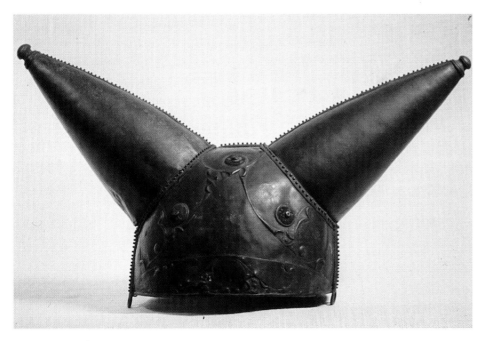

Waterloo helmet. The helmet gets its name from the location where it was discovered, in the river Thames, under Waterloo bridge, and it probably dates from the late first century AD. Again, the Roman characteristic of enamel inlay is apparent on the bronze body of the helmet. It is thought to be a ceremonial piece, rather than an actual war helmet, since it is too small in size to have been worn by an adult warrior (British Museum, London).

above all others, with the conversion to Christianity of the Irish people. St Patrick was the son of a Roman deacon living in Britain, but he was captured as a young boy and brought to Ireland as a slave. His own story of the event is recorded in *The Book of Armagh*. The saint's *Confessio* reveals how he subsequently returned to Ireland in later years as an evangelist of the Christian faith and bishop of the Roman Church. Patrick was the first of many missionaries to come to Ireland. Within a century the Irish Church had come into full bloom, its character less determined by territorial boundaries and patterns of civil administration than by family or tribal influences. A distinctively Irish, non-conformist monasticism became the ecclesiastical unit and monasteries began to appear throughout the country. Many important monasteries such as Clonmacnoise and Durrow were founded during this period in southern Ireland. At the same time, numerous monks took it upon themselves to promote their Christian beliefs among British and Continental inhabitants recovering from the disintegration of Roman authority.

In 563, St Columba (Columcille) travelled from Ireland to Iona off the coast of Scotland and founded a monastery there. Other missionaries crossed to England and also as far afield as Switzerland, Italy and Gaul; many returned to Ireland having absorbed new ideas from their foreign journeys.

The introduction of iron to the Irish by the Celts of central Europe enabled, among other things, the production of more efficient stone carving implements. Little or no stone carving exists from the Bronze Age and only a few sculptures pre-date AD 700. Before the dawning of Christianity, Celtic stone carvings were of pagan gods and were translations of basic designs used in metalwork. The Janus-headed idol

Opposite:
The Tanderagee stone figure may have come from a pagan shrine on the hill of Armagh. It dates sometime between 250 BC and AD 250 (St Patrick's Cathedral, Armagh).

A page of Saint John's Gospel in the *Book of Mulling*. The manuscript was probably produced in the early eighth century (Trinity College, Dublin).

from Boa Island, Co. Donegal, is a good example of early pagan Celtic stone sculpture, as is also the phallic-shaped, carved stone at Turoe, Co. Galway. The latter is thought to be a cult stone of worship and is decorated with curvilinear La Tène patterns from the early Iron Age. Stone heads, in particular, provide the most plentiful illustrations of the human form; examples of representative human forms in any medium are rare in early Celtic art. The stone figure from Tanderagee,

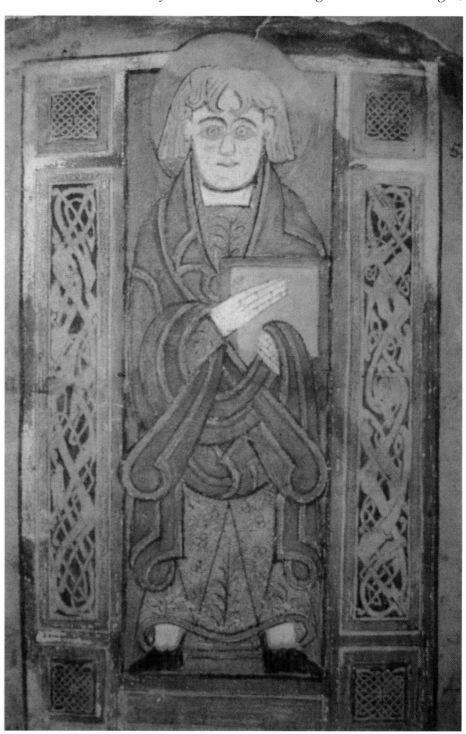

Opposite:
A shrine was built in Roscrea for the *Book of Dimma* in the twelfth century. The shrine is formed of decorated bronze plates. The design was altered in both the fifteenth and nineteenth centuries. It is kept with the manuscript at Trinity College Library (Trinity College, Dublin).

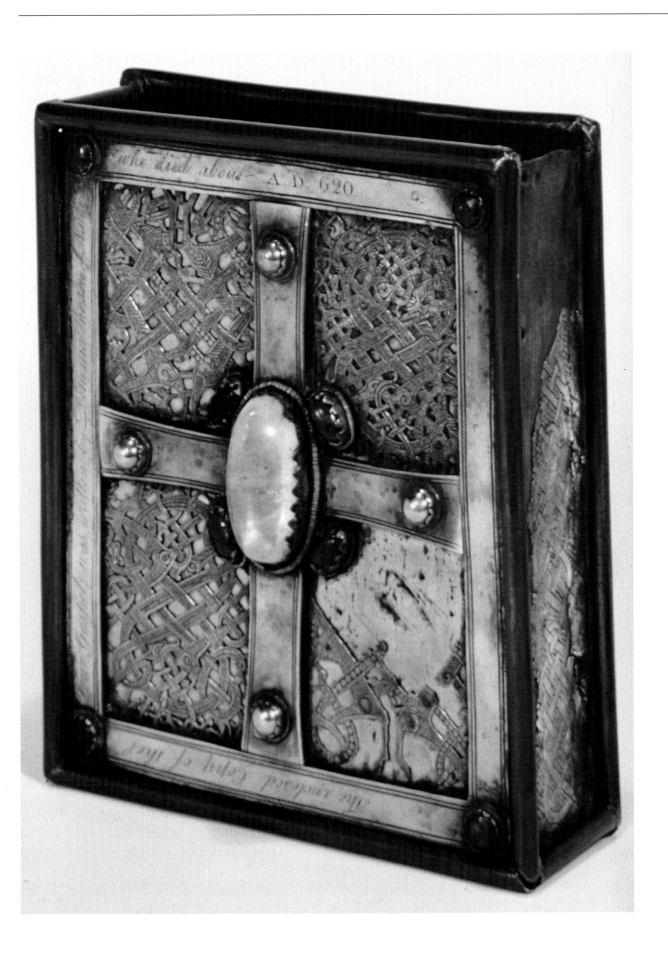

The initial page of the Gospel of St Mark from the *Book of Durrow* (Trinity College, Dublin).

Co. Armagh, is a rather menacing example of a pagan deity. It was found in a pre-Christian shrine, although its exact age is difficult to establish. The pagan Celts believed in tree gods and water goddesses, so that the seeds of Christianity fell into a soil fertilized by centuries of nature worship.

With the building of monasteries, the talents of Celtic craftsmen were increasingly diverted to supply the needs of the Christian monks. Small stone churches were required and the earliest examples of Christian stone carvings were large granite slabs, descended from pagan standing stones, used to commemorate the dead. Christian stones in Britain and Ireland are either inscribed in *ogham*, a primitive form of Irish writing, or in very basic Latin.

Gradually, the monasteries began to introduce carved stone crosses as an exclusive symbol of their faith, prominently displayed within the boundaries of the monastic enclosure. Often these early stone crosses were makeshift in decoration, with simple spirals, knots and primitive designs on the cross, sometimes enclosed within a circle. There was little attempt to shape the flat stone. Only at the end of the sixth century did more ambitious designs appear and the cross emerge from the crude slab as a carved shape. A highly accomplished example of the early form is the cross-inscribed pillar stone at Reask, Co. Kerry. It is thought to date from the seventh century, when Christianity had taken a firm hold, but crosses had not yet taken on their ultimately highly sophisticated shape, prompted by more elaborate designs of Late La Tène metalwork and a greater dexterity of the Celtic artist in stone sculpture. These crosses, the High Crosses of Ireland, are examined in more detail in the final chapter.

The groups of monks travelling overseas to promote their Christian message no doubt instigated the need for portable liturgical scripts. Illuminated manuscripts came into being as a medium through which these men might spread the Good News abroad. Missionary activity led to an enormous increase in output for skilled Irish artists and the monasteries became the main patrons of Irish art. Irish monks employed the services of the artists hitherto employed by the Celtic pagan chieftains. The designs of these craftsmen had already appeared on many kinds of pagan metalwork, but the artists were now encouraged to transpose their spiral patterns, interlaces and animal figures, first worked out on slips of bone or pieces of metal, on to the manuscripts.

Christianity contributed additional, innovative elements. With it came a new Latin language, a knowledge of writing and a whole host of religious symbols, including the aforementioned sign of the cross, or *Chi-Rho*. Craftsmen passed their skills to the monks who quickly grew to become competent artists themselves. In time, many of these ecclesiastics performed the dual tasks of artist and scribe.

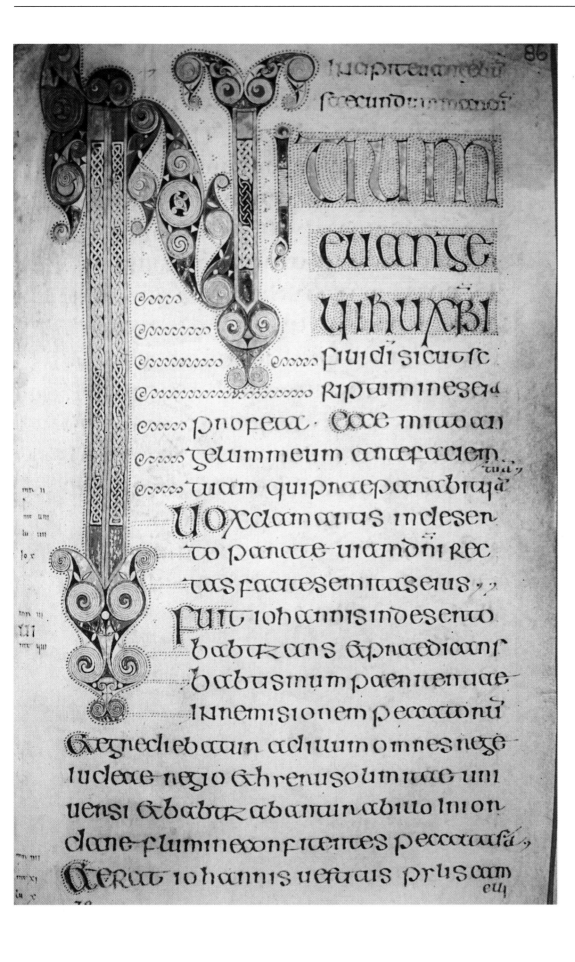

86

INCIPIT EUANGELIUM
SECUNDUM MARCUM

INIUM

EUANGE

LII IHU XPI

FILII DI SICUT SC

RIPTUM INESA

PROFETA · ECCE MITTO AN

GELUM MEUM ANTEFACIEM

UIAM QUI PRAEPARABIT UIA

UOXCLAMANTIS INDESER

TO PARATE UIAM DNI REC

TAS FACITE SEMITAS EIUS ·

FUIT IOHANNIS INDESERTO

BABTIZANS ET PRAEDICANS

BABTISMUM PAENITENTIAE

IN REMISSIONEM PECCATORUM

ET EGREDIEBATUR ADILLUM OMNES REGE

IUDEAE REGIO ET HIERUSOLIMITAE UNI

UERSI ET BABTIZABANTUR ABILLO INIOR

DANE FLUMINE CONFITENTES PECCATA SUA ·

ET ERAT IOHANNIS UESTITUS PILIS CAM

ELI

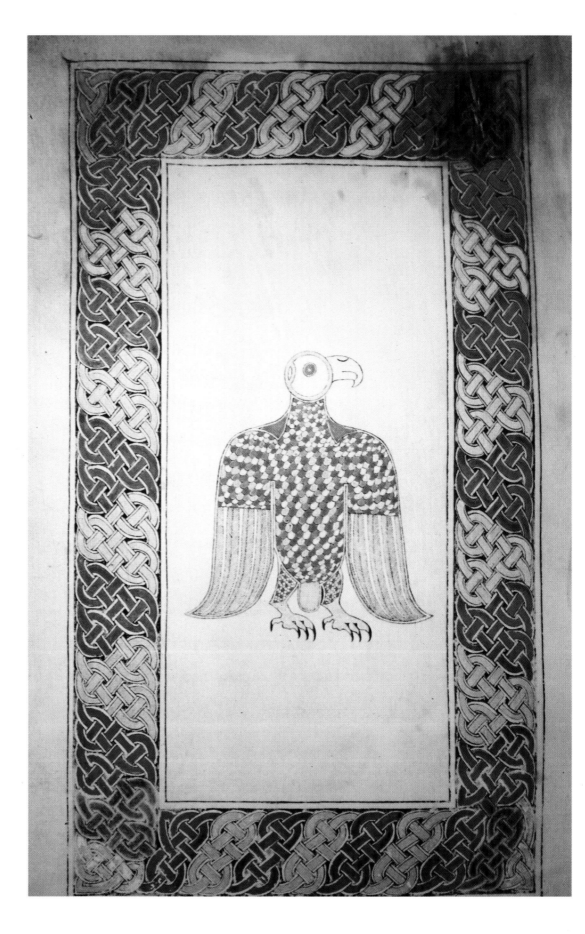

It is difficult to date accurately many of the Celtic manuscripts of the Christian period, since the artist was nearly always encouraged to remain anonymous. A further complication lies in the fact that some works are clearly collaborations of several artists and scribes, showing no individual stylistic traits which might help identify a single illuminator. The earliest Irish illuminated manuscript is known as the *Cathach*. It is reputed to be the work of St Columba's own hand. The saint's biographer, in particular, asserts that St Columba confined himself to his cell towards the end of his life in order to work on a book of psalms. Many art historians however, believe that the manuscript is the work of another scribe and of a later period, perhaps the early seventh century, after the saint's death in 597. In common with many other manuscript texts, the *Cathach* has not remained intact over the centuries. It is a fragmentary Psalter, of which only fifty-eight pages of the psalms now survive. The basic colours and illuminations foreshadow a style that was to become more and more extravagant with the passing of time. From the red and brown inks of this particular manuscript, artists moved on to employ shades of yellow, green, blue and purple in the decorating of initials and later portraiture of the four Evangelists. Many of the pigments used on subsequent Gospel texts were very expensive and difficult to acquire. Lapis lazuli, from which the monks obtained a blue pigment, had to be imported from as far away as the Arab world. The young calf skin known as vellum, on which the ornate letters were inscribed, was also precious and costly. These later religious manuscripts were obviously revered and the artists who produced them held in very high esteem.

The *Cathach* is an unsophisticated, rather small book, written in Latin, in a very early form of Irish script and evidently with a very functional purpose in mind. The decoration of initials is a practice known to have come to Ireland from the Mediterranean. The antique book *Vergilius Augusteus*, a fourth-century Italian manuscript, provides early examples of this tendency, employed with some degree of novelty in the *Cathach*. Each psalm starts with a large initial, followed by letters gradually diminishing in size and merging with the overall text, hence the term 'diminution' is applied to the style. The initials are very simply decorated with spirals, animal heads, peltas and crosses, each one surrounded by a line of tiny red dots, which was a feature borrowed from the Orient. Some of the hollows of the larger letters have been filled in with a yellow pigment. The manuscript of the *Cathach* is now housed in the Royal Irish Academy of Dublin. A special shrine of wood and beaten silver panels was made for it in the eleventh century and is kept separately at the National Museum of Ireland.

A number of Gospel books have been discovered which, like the *Cathach*, display limited ornamentation and appear to have been used

The Eagle Symbol of Saint John the Evangelist in the *Book of Durrow*, introducing the last of the four Gospels (Trinity College, Dublin).

exclusively for devotional purposes. Pocket-sized Gospel books, intended to be carried around by the evangelist monks, are unique relics of the early Irish Church. There must have been a great many such liturgical books in the monasteries at one point, but only eight examples have survived the ravages of time, not all of them complete. Of these, the *Book of Mulling* and the *Book of Dimma*, both now kept at Trinity College, Dublin, are the most well known. The Books share several common characteristics. Each of the Gospels is preceded by a portrait or symbol of the appropriate Evangelist. This tradition appears again in the later, more spectacular, illuminated manuscripts. The Gospel Books share with the *Cathach* a use of ornamental initials. In this case, the initials introduce each separate Gospel. The Books fully avail also of the restricted space on the page and the leaves are entirely filled with script. Many words are abbreviated as a result and there is less attention to formal detail.

Another common feature is the absence of proper binding of the text. It is presumed that the monks found it more convenient to handle loose leaves and preferred leather casing to stitched spines. This ecclesiastical precedence, which undoubtedly led to parts of the Books being exchanged or lost, provides a plausible explanation as to why the St John's Gospel in the *Book of Dimma* is written by a different scribe to the other three Gospels.

A twelfth-century manuscript describing the life of St Cronan, founder of the Roscrea monastery in Co. Tipperary, records how the *Book of Dimma* came to be written. The account of its creation however, would seem to contradict substantial evidence of collaboration. The Book is not the work of a single scribe as this manuscript suggests. The story unfolds that St Cronan requested 'Dymma', a monastic scribe, to produce a Gospel Book within a single day. He miraculously achieved this task because God did not allow darkness to fall for forty days. During this time, 'Dymma' never became weary, had no desire for food or water, and completed his work as if he had devoted only twenty-four hours to it. The first three Gospels of the Book are all in the same hand, the last Gospel is markedly different. The reliability of the twelfth-century manuscript account is also further challenged by the fact that an original scribe's signature has almost certainly been deleted to make room for the name of Dymma.

The *Book of Mulling* was originally formed of five parts, each of varying length. The four Gospels are prefaced by a separate section for Canon tables and prayers. The Book was very badly damaged by the time it was acquired by Trinity College Library in Dublin in the eighteenth century and only eighty-four pages now remain, including four loose pages with portraits of the Evangelists, which may or may not have formed part of the original text. The *Book of Mulling* is almost certainly Irish and it seems to have come from the monastery of Tech

The luxurious textured effects produced by the artist allowed these pages to be christened 'carpet pages'. They became a popular feature of later manuscripts (Trinity College, Dublin).

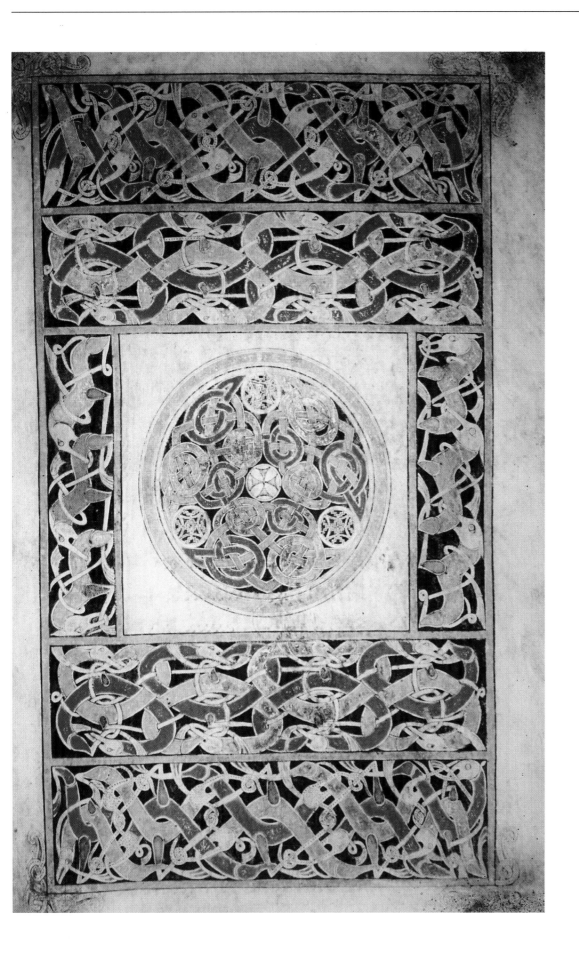

Moling in Co. Carlow in the east of Ireland. Once again, controversy surrounds the exact date of the manuscript. The only Moling recorded in the history of the time was indeed the founder of a monastery in Co. Carlow, but the year of his death, 697, is too early for a manuscript of its type to have been written. Scholars tend to agree that the Gospel Book was produced in the early eighth century and the name of Moling copied on to the colophon (imprint) page at the end of St John's Gospel. It is clear that the prayers at the end were also transcribed at a later date. One of the end pages of the surviving text is a reproduction of a map of an early Irish monastery attesting to the importance of stone crosses in early Christian enclosures. The map, comprising two compass circles, has no fewer than twelve crosses standing within the grounds of Tech Moling.

By the middle of the seventh century, Irish monasteries continued to exist alongside Episcopal dioceses, but they were no longer the humble, primitive settlements of the fifth century. Monastic communities had evolved into rich and powerful storehouses of artistic treasures and they supported many lay dependants. Increased Christian links with the Continent brought new patronage and wealth and also substantially increased the eclecticism of Irish monastic art. Celtic society, in its new Christian form, flourished without interruption. While maintaining its stylistic independence, Ireland increasingly looked to the Anglo-Saxon world for instruction in filigree design, gilding, granular work in gold, the use of ribbon interlace and complex casting imitating deep engraving. The standards of technical perfection now achieved in metalworking were brought to bear on the illuminated manuscripts. Designs were laid out with compasses and built up with intersecting circles and arcs, as they were in the field of metalwork. A close inspection of the manuscripts reveals tiny perforations left by the compass. Ultimate La Tène scrollwork remained a vital decorative feature, but the skills acquired from the Germanic world allowed for far more colourful, highly accomplished work.

Little Celtic art of exceptional merit seems to have been produced in Britain after the seventh century. Except for the Picts and Scots of northern Scotland, the Irish monasteries were responsible for almost all outstanding examples discovered in Britain relating to this period. Late seventh-century and early eighth-century manuscripts, among them, the *Book of Durrow*, the *Book of St Chad*, otherwise known as the *Lichfield Gospels*, and the *Lindisfarne Gospels*, perfectly illustrate the new matured style of manuscript illumination. The mission of Aidan of Iona in the 630s to the ancient kingdom of Northumbria in northern England was especially important in its flowering. The monks who arrived in Northumbria towards the end of the middle of the seventh century quickly set about converting the Anglo-Saxon tribes to the Christian faith and many monasteries sprung up in England as a

The *Lindisfarne Gospels* were produced after the *Book of Durrow*, probably around AD 700, and rely heavily on patterns and ideas from the earlier manuscript. The 'carpet page' is a direct imitation, although the style and ornamentation are somewhat more developed (British Museum, London).

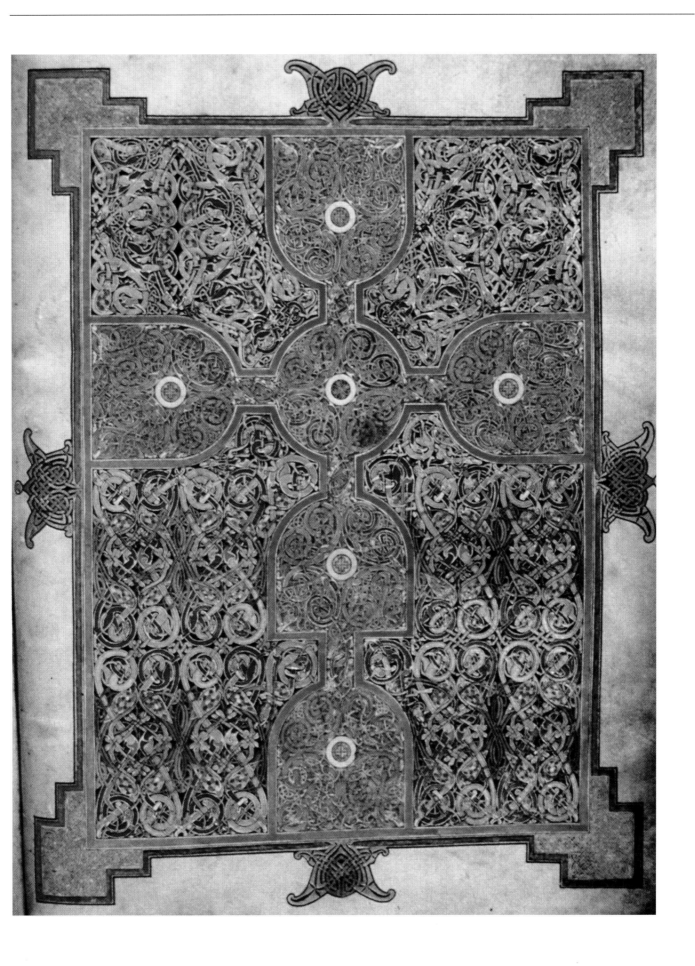

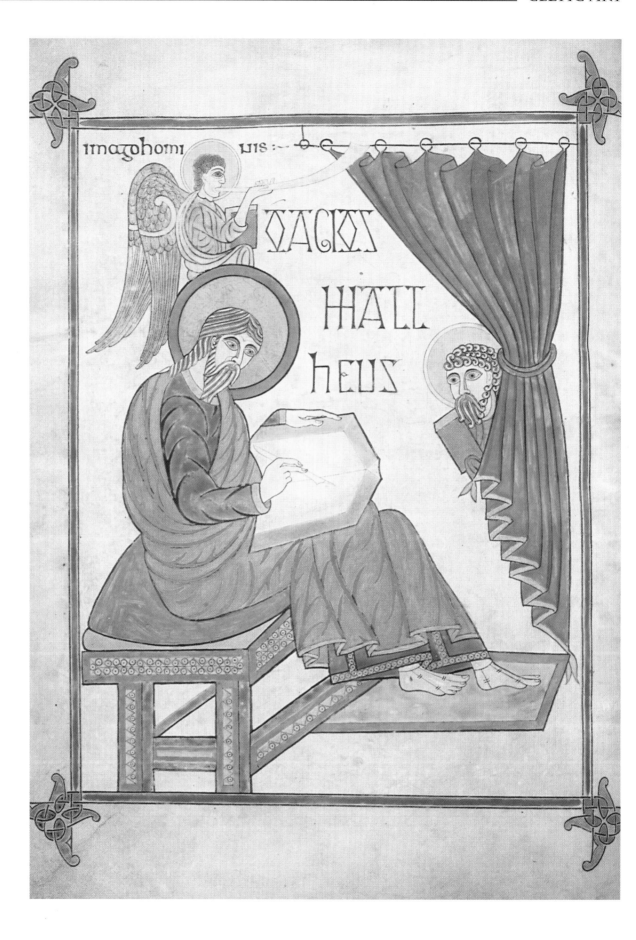

result, including Jarrow, Whitby, Old Melrose and Lindisfarne. It is almost certain that the *Lindisfarne Gospels*, dating from around AD 700 were produced in Northumbria and possibly parts, or all, of the *Book of Kells* were illuminated at the same monastery.

Both manuscripts were definitely created in an Irish cultural setting, richly imbued with new Anglo-Saxon and Mediterranean influences. The origins of the ornamentation of the *Book of Durrow*, *Lindisfarne* and *Kells* are easily traced to the patterns adorning the helmets, shields and harnesses of the Romans, whereas animal motifs are more obviously derived from the colourful animal style of Anglo-Saxon metalwork. For the first time, however, there is a complete blending and harmonizing of borrowed decorative elements, transposed with great artistic adroitness on to the manuscripts.

The *Book of Durrow* is a far more elaborate manuscript than any of its predecessors. It is arguably the finest early example of manuscript illumination in a progressively elaborate sequence of works leading towards the extraordinary *Book of Kells*. The manuscript, again a copy of the four Gospels, was preserved for many centuries in the Irish monastery founded by Saint Columba at Durrow, Co. Offaly. Its discovery in Ireland has led many to believe that it was created there, but it may also have been worked on in Northumbria. Wherever it was produced, it was created under the direction of an artist-scribe schooled in Ireland. If it *was* written in Northumbria, it demonstrates just how much the Irish monks had managed to teach the English converts. The small-sized text, written in Latin Vulgate, was reputedly discovered and retained by a farmer for a good many years, who used to dip it in the drinking water of his cattle as a cure for their ailments. Eventually the manuscript was passed to one of Cromwell's bishops who presented it to the library at Trinity College, Dublin.

Despite a rather limited range of colour, mainly yellow, vermilion, brownish-black and green, the manuscript employs far more lavish illumination and design than the earlier pocket Gospel Books. For the first time, initials are decorated not only with simple spirals, but with plaited, involved interlacings which extend the contours of the letters dramatically. Initials are also enhanced by tiny red dots, first seen in the *Cathach*, but here the dots are more skilfully distributed to create a depth of colour, while avoiding a heavy, solid effect. The ornamental animals in the *Book of Durrow* evolve from spirals and abstract interweaving curves to become strangely contorted beasts, set against the background of plain, cream-coloured vellum. There is an astounding sensitivity to the value of colour contrast in this particular Book. In later manuscripts, for example, the *Book of Kells*, the artist was not so obliged to exploit the potential of a very limited palette.

A 'carpet page', richly textured and displaying a great love of pattern, introduces each of the Gospels. These carpet pages were a new

An illustrated page from St Matthew's Gospel. More vibrant colours are used compared to the *Book of Durrow*, including here vivid shades of red and blue (British Library, London).

First page of the Gospel of Saint
Matthew in the *Lindisfarne Gospels*
(British Library, London).

concept and were to be repeated in other later manuscripts. A procession of biting, long-snouted animals, interlocked in a chain pattern, adorn one such carpet page. It is clearly influenced by Germanic art, yet the design is more elaborately executed than anything in Anglo-Saxon metalwork. Another carpet page is entirely covered with traditional ultimate La Tène motifs, including trumpet spirals, peltae and bird-headed scrolls, more obviously of Mediterranean origin. The Evangelists' symbols of man, calf, lion and eagle, immediately follow the carpet pages and these too, are a feature further developed in manuscripts to follow. The illustrations of the Evangelists are non-naturalistic, the Celtic artist had no difficulty in distorting the human form, even that of saints. The portrait of St Matthew in the *Book of Durrow* reveals a human form with no arms, the body is oblong and bell-shaped. The robe of the Evangelist is decorated in a mosaic pattern of red and yellow squares influenced, no doubt, by Roman enamelling and *millefiori* glass designs.

Two more manuscripts deserve a brief mention here before moving on to a lengthy discussion of the monumental *Book of Kells* in the next chapter. Both the *Lindisfarne Gospels* and the *Lichfield Gospels*, (also known as the *Book of St Chad*), display an impressive diversity of styles and share many similar characteristics with the *Book of Durrow* and the *Book of Kells*. The affiliation may be attributed to the fact that the manuscripts all came from Columban monasteries, although there is some argument that the *Lichfield Gospels* is a Welsh creation. The *Lindisfarne Gospels* which is even more luxurious in design than the *Book of Durrow*, was almost certainly written by Eadfrith, Bishop of Lindisfarne from AD 698 to 721. Unlike the *Book of Chad*, the Gospel texts are preserved in impeccable condition. They employ a whole range of new colours, with several shades of blue, red and yellow. There are also several compass compositions and animal ornaments in the Gospels, used as a powerful means to convey the symbolism of a Christian art never allowed to deteriorate into monotony.

On the carpet page preceding St Mark's Gospel, obvious compass pricks and ruler designs on the page are apparent, evidently intended to guide the hand of the illuminator. The *Lichfield Gospels* again shows the use of a compass in the laying out of designs. Many of the surviving pages are damaged, the colour, in particular, has faded badly and those pages after the beginning of St Luke's Gospel have disappeared. Although the manuscript dates from the early eighth century, it did not pass to Lichfield Cathedral until the tenth century and it is fondly described as a 'wandering manuscript'. Some Welsh notes written on the manuscript almost a century after it was first written record that it was exchanged for a horse and subsequently passed to the monastery at Llandaff. It is believed to be the oldest liturgical text still in use.

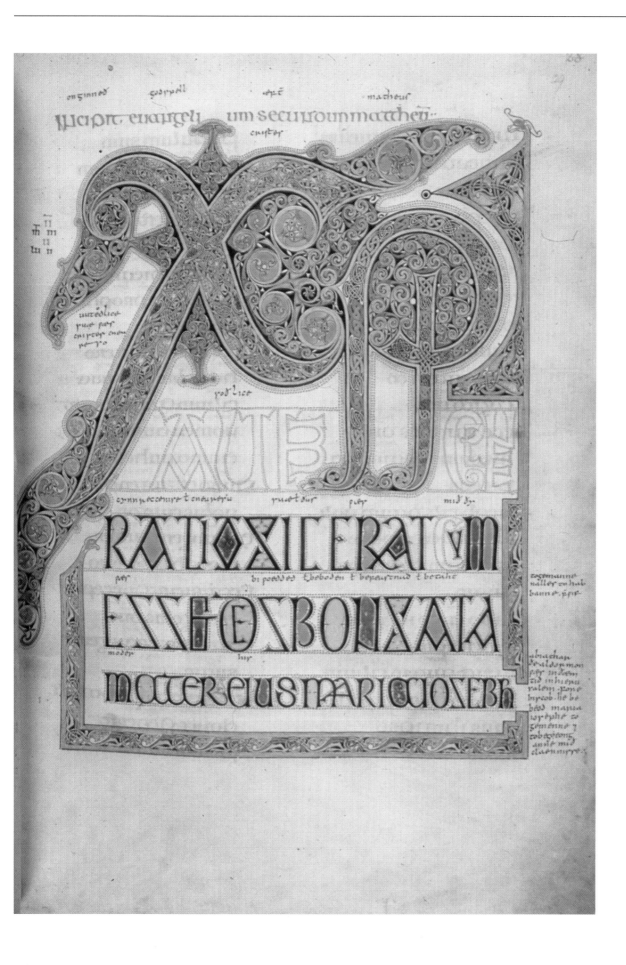

CHAPTER 4

The Climax of Celtic Art

The seventh century, as we have seen, was an important period for Celtic art. A truly Irish tradition emerged and infiltrated parts of evangelized Britain, but insular Celtic art in England, with the exception of Pictland in the north of Scotland, generally moved towards obscurity.

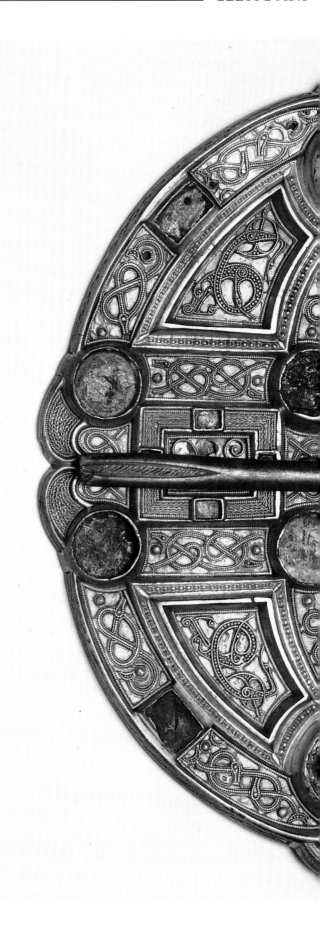

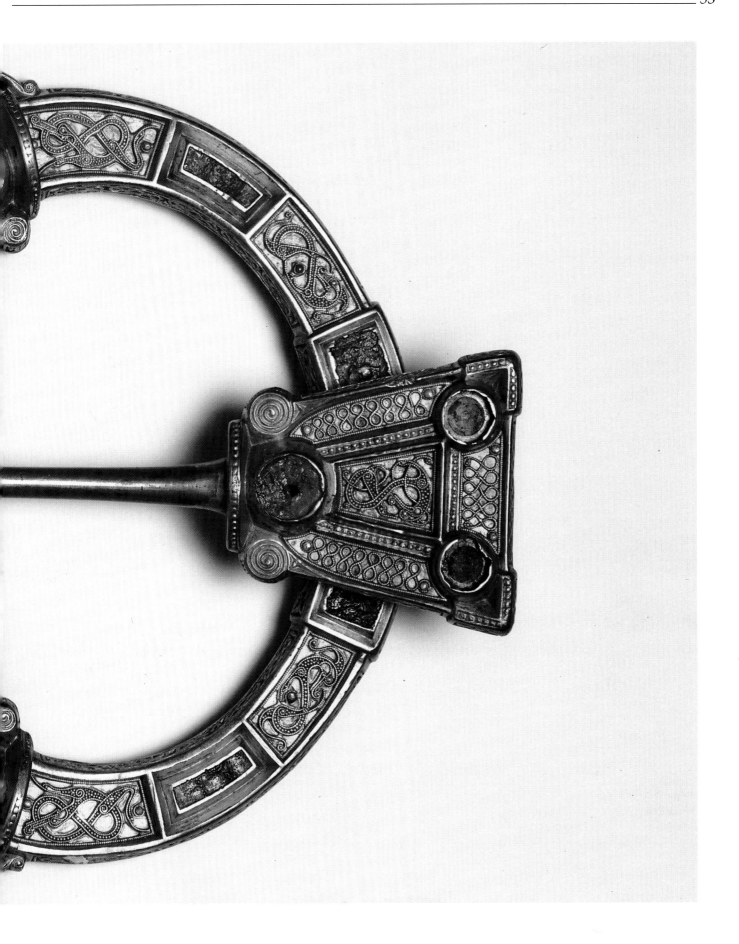

There is little evidence of a firm native tradition after the seventh century in either metalworking, sculpture or manuscript illumination in England. Certainly, after the middle of the sixth century, ornamental metalworking of an insular Celtic nature had disappeared in south-west England and Wales, and by the seventh century output had also declined dramatically in southern Scotland. The peak of Celtic creativity occurred in Ireland, on the other hand, in the eighth and ninth centuries.

Northern Scotland, still inhabited by a resilient Pict population, produced its own brand of 'Celticized' art, influenced by missionaries from Ireland, yet retaining a unique Pictish symbolism and design. The large illuminated manuscripts were produced at this time. The apogee of Golden Age manuscript illumination is undoubtedly the *Book of Kells*, but some of the finest pieces in ornamental metalwork from early medieval Europe were now also produced. The brilliance in metalwork achieved, mostly by Irish craftsmen during the eighth and ninth centuries, is equally astounding to the powerful complexity of the later manuscript designs, and merits considerable exploration.

From the sixth century onwards, metalworking flourished in Ireland. Its direction affirms the embrace of styles and trends far removed from the original simple roots of the artist. In Ireland, as has been mentioned before, monks, fired with missionary zeal, readily exposed themselves to foreign influences which were subsequently imparted to the Celtic artists either within, or outside of, the monasteries. An early example of metalworking with a religious theme is the St John's Crucifixion Plaque from Athlone in southern Ireland. This late seventh-century piece, crafted in gilt-bronze, of Christ is decorated with spirals in low relief, his face is stylized and his body proportions distorted in typical Celtic fashion.

He is attended by two angels above him, and two more figures below him, one carrying a spear, the other a sponge. The Plaque may have been used as a book cover, or it may have decorated a shrine. Metalworking was not just confined to religious artefacts, however, and much of the craftsman's time was employed in the making of secular objects. A group of zoomorphic penannular brooches has survived from sixth-century Ireland and they show an increasingly sophisticated design, including the use of red enamel and miniature work. Fifth-century personal ornaments from Pictland, including a hand pin, chain and bracelet are more basic, but imitate a Roman preference for silver.

Ring pins and penannular brooches were the common dress fastening throughout the sixth century. At first, they were plain and limited in decoration, but gradually they became more elaborate. In the seventh century, a distinct change of design occurred. Brooches now became fully annular, forming a complete circle without any

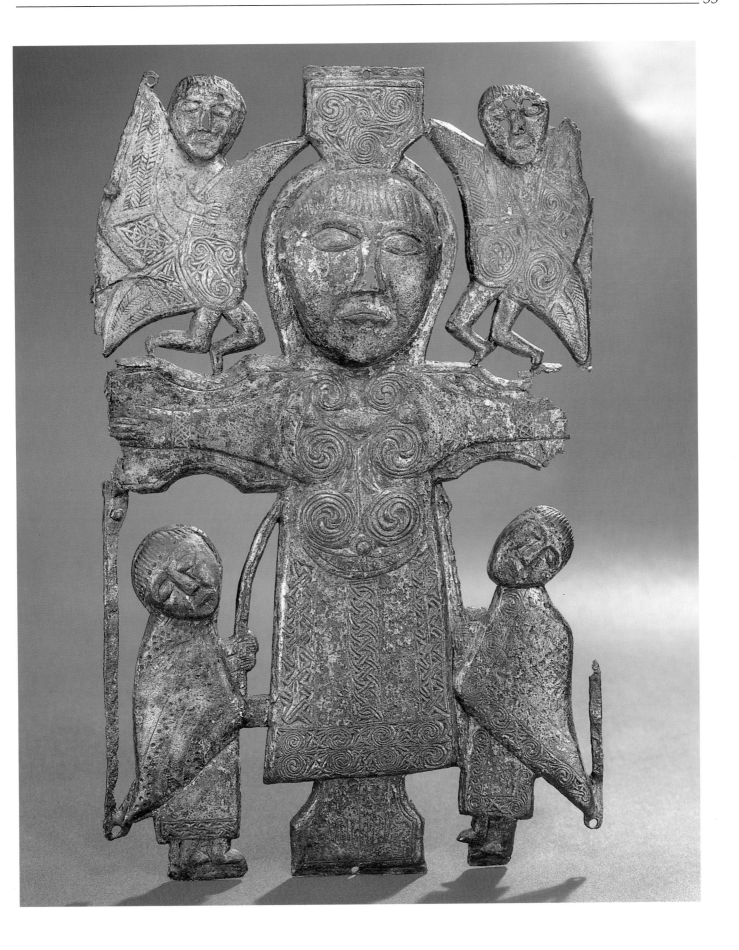

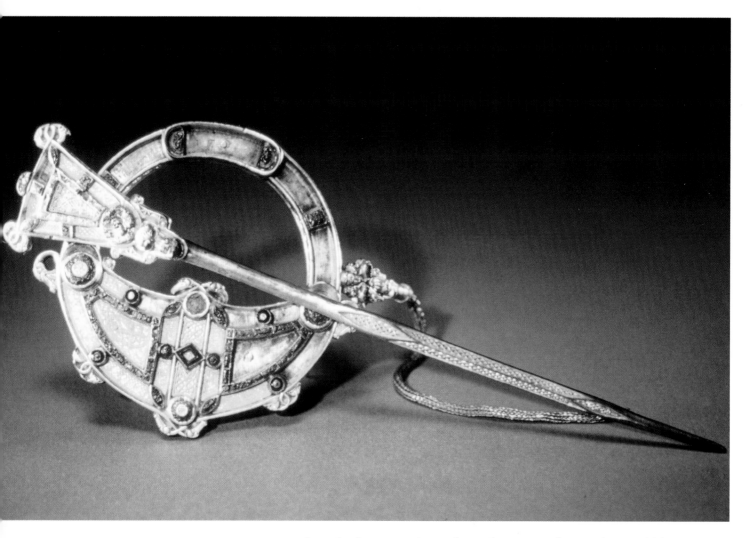

The Tara brooch is a far more sophisticated example of pseudo-penannular than the Hunterston brooch. The tradition of annular brooches evolved in Ireland sometime in the seventh century and increasing attention was paid to their elaborate decoration (National Museum of Ireland, Dublin).

Opposite:
The detail of the Tara brooch is quite astounding. Back and front are decorated with intricate animal interlacing, spirals and red and blue enamel studs (National Museum of Ireland, Dublin).

opening. At the same time, the techniques of granular and filigree gold work reached the Celtic areas from Anglo-Saxon England. Two of the most well-known of the annular type of brooch, also known as pseudo-penannulars, are the Hunterston brooch and the Tara brooch, the latter of which is described as the most outstanding example of minute perfection ever achieved in Celtic jewellery design. Both brooches were probably produced by an Irish school of metalwork based in the midlands of Ireland.

The Hunterston brooch was discovered on a beach in Ayreshire in 1830. Because of similar features to the *Lindisfarne Gospels*, including birds' heads, snouted beast heads and an overall mathematical design, it has been suggested that the silver-gilt brooch was produced at the end of the seventh or early eighth century. Many scholars believe the brooch to be Irish and suggest that it was taken to Scotland by Norse invaders, where it is now housed in the Royal Museum at Edinburgh. Its design was almost certainly influenced by Saxon workmanship, leaning towards the use of Celtic patterns and motifs. It is less extravagant than the Tara brooch and exudes a restrained, almost spiritual

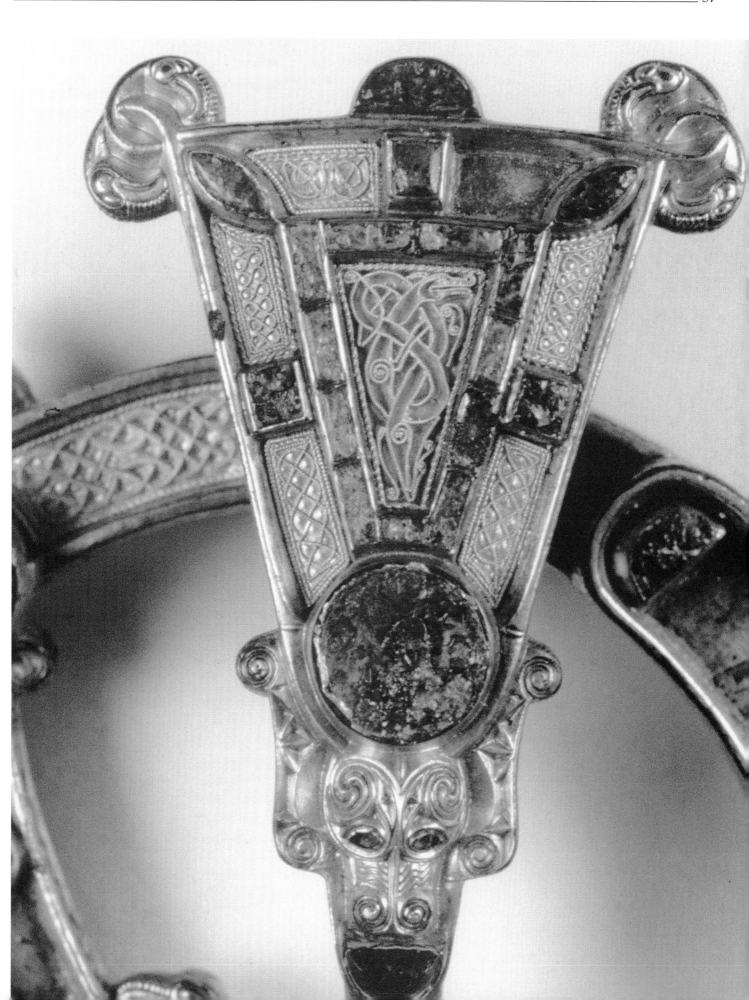

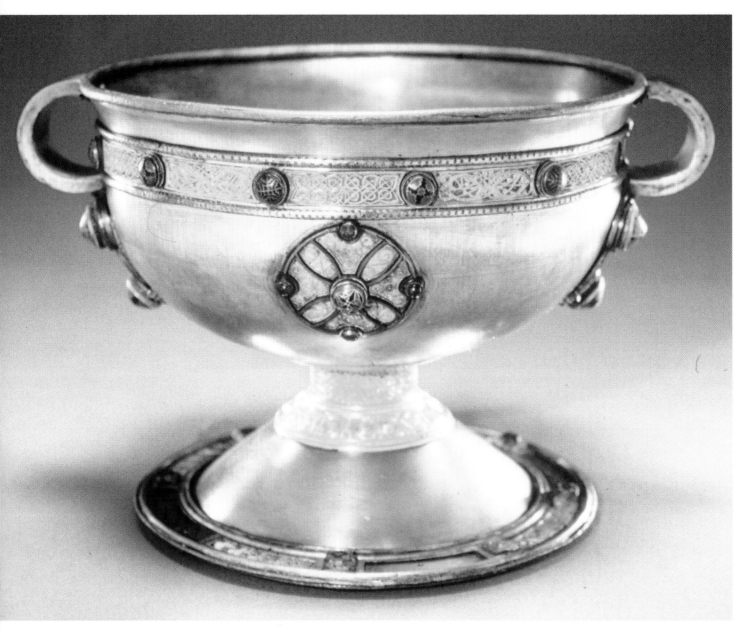

The Ardagh chalice appears to have been deposited in field in Co. Limerick by Viking raiders. It was discovered last century and is considered the equivalent in metalwork to the most accomplished illuminated manuscripts (National Museum of Ireland, Dublin).

aura, whereas the Tara brooch emanates a lavish, brazenly luxurious quality.

The Tara brooch shares with the Hunterston brooch several characteristics of the 'Lindisfarne style'. Long-beaked, long-legged birds are an integral part of the decorative design, as are the long-snouted animals, both of which occur in the *Lindisfarne Gospels*. The Tara brooch has no Christian significance however, and also no connection with Tara, the seat of the High Kings of Ireland. This type of brooch may have been worn equally by bishops of the church, or by kings and queens. It was actually discovered in the nineteenth century in Bettystown, Co. Meath, in a wooden box near the banks of the River Boyne, along with several other objects of personal ornament. The brooch is the most spectacular example of the developed Irish type of

annular ornament. Photographic reproductions lead one to believe that it is much larger in size, yet it is only nine inches in length and three and a half inches in diameter.

The miniature work is quite astounding, given the limited surface space, and it covers both the front and back of the brooch which is an unusual feature to modern eyes. It was originally probably one of a pair, worn on a tunic and joined together across the shoulders by a silver chain. Part of this 'safety chain' still dangles from the piece. The body is made of silver and is elaborately decorated with gold filigree, granulation, and enamel, inset with glass and amber studs. Bestial imagery is prominent, but in a most abstract form, characteristic of Celtic craftsmanship. Animals with protruding eyes and curling lips fill the miniature spaces. Incredibly intricate designs of varying inter-laces are achieved within the space of only a few centimetres. Copper has been used in some of the larger panels, enhancing the gold and silver range of colours. Unfortunately, a number of the panels are now empty, but those that remain reveal a remarkable precision of design. The brooch was probably made in the early eighth century.

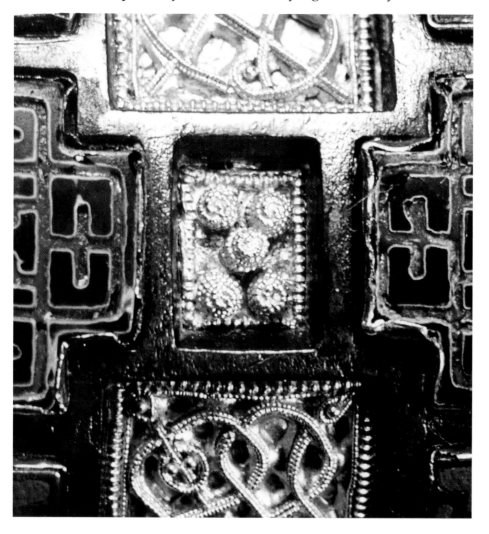

Detail of the handle of the Ardagh chalice with minute rectangular-shaped panels of embossed silver and copper, each varying in design and colour (National Museum of Ireland, Dublin).

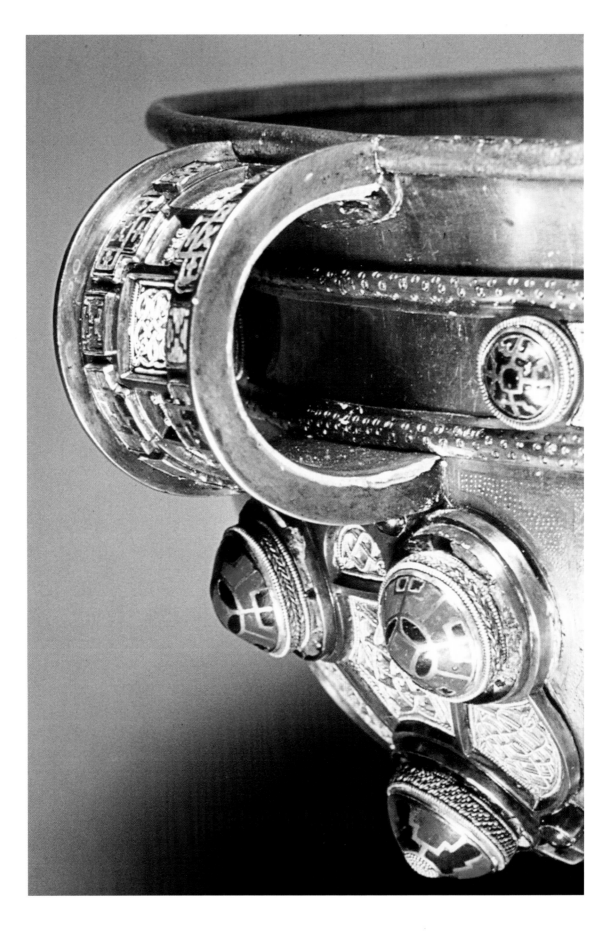

Another remarkable example of Celtic workmanship in silver is the Ardagh chalice. Many scholars of Celtic art consider it a parallel piece, in terms of sheer artistic perfection, to the superb *Book of Kells*. The chalice may well have come from the same school of metalwork as the Tara fibula, since it shares the same decorative supremacy. It is quite complex in structure and consists of three main parts – a large bowl of beaten silver, a stout stem, and a broad foot at the base. The chalice was discovered by a young Limerick boy digging potatoes in a field in 1867. It was part of a larger collection of objects, including a smaller, plain bronze chalice and four penannular brooches, thought to have been abandoned there by Viking raiders. The chalice is seven inches high and nine inches in diameter. Although elaborate in design, it is at the same time, delicate and restrained. The Celtic art scholar, Françoise Henry, aptly describes the unique appeal of this particular liturgical vessel. She writes,

> *The whole balance of the composition has still the strength and restraint of the best seventh century work and belongs to that moment of perfection that marks the turning point between a youthful, impetuous, though already experienced art, and a surfeited and over-elaborate decoration.*

Much of the large silver bowl is quite plain, there is an absence of Tara brooch animal motifs and there is no *millefiori*. The plain design is however offset by the most intricate, trailing, gold filigree work on each of the ten panels below the gilt-bronze rim. The filigree work echoes that of Anglo-Saxon England. The chalice has two loop handles offering a contrast of rich colour and decoration. These handles are secured to the bowl by plaques lavishly ornamented with glass studs in red, blue, green and yellow, each one based on a design of the cross. The studs are interspersed with tiny frames of gold filigree work. The names of the twelve Apostles are carefully engraved in Latin on the silver body. Two circular medallions decorate the sides of the chalice and a second gilt-bronze decorative band runs around the foot. The Ardagh chalice dates from around AD 700 and is now kept at the National Museum of Ireland.

It is thought that the Derrynaflan chalice may also have been deposited by Viking looters. Up until 1980, the Ardagh chalice was the single most important liturgical vessel to have been discovered, but an excavated monastery site at Derrynaflan, Co. Tipperary, revealed a new ecclesiastical hoard. A silver chalice, a paten (the plate used to hold the bread of the Eucharist), and a silver stand were retrieved from the soil, together with a bronze basin and gilt-bronze strainer. The chalice is not so expertly crafted as the Ardagh chalice and there is some speculation about its date. It is almost certain that

The handle escutcheon of the Ardagh chalice revealing red enamel studs and intricate gold filigree interlacing (National Museum of Ireland, Dublin).

the silver paten and stand belong to a different period, most likely the early eighth century, the same period as the Tara brooch. The chalice cannot have been made before the late eighth century or possibly even the ninth century. It is crude in design, while the paten and stand share many of the characteristics of the Tara brooch, including trinchinopoly – a knitted wire effect similar to the chain of the Tara brooch, gilt and zoomorphic interlace, enamel studs and running scroll patterns.

One further type of religious artefact adorning Christian altars remains to be considered. A common object in early Christian churches was a type of reliquary – a house-shaped casket, rather like a miniature version of the church itself. The reliquaries were venerated and believed to have miraculous powers. They were usually carved of wood and then embellished with metal, either silver, gold, or bronze. The metal sheets were decorated with studs of amber and also enamels. The reliquary discovered in Co. Limerick, known as the 'Emly shrine' is made of wood and silver plates with gilt-bronze and enamel mountings. One of the finest examples of a reliquary however, is the Monymusk reliquary, a small box in the shape of a house, with enamelled hinges on the straps and a pair of birds' heads on the gabled roof in the style of the Tara brooch. The reliquary probably belongs to the second half of the eighth century and many believe it to be the only surviving

The Derrynaflan paten and stand are superior in quality and design to the chalice discovered alongside them. No other examples of this sort of liturgical plate exist from this period (National Museum of Ireland, Dublin).

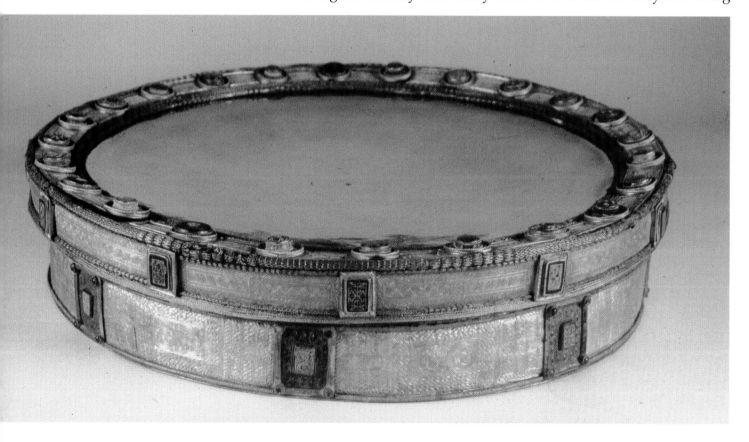

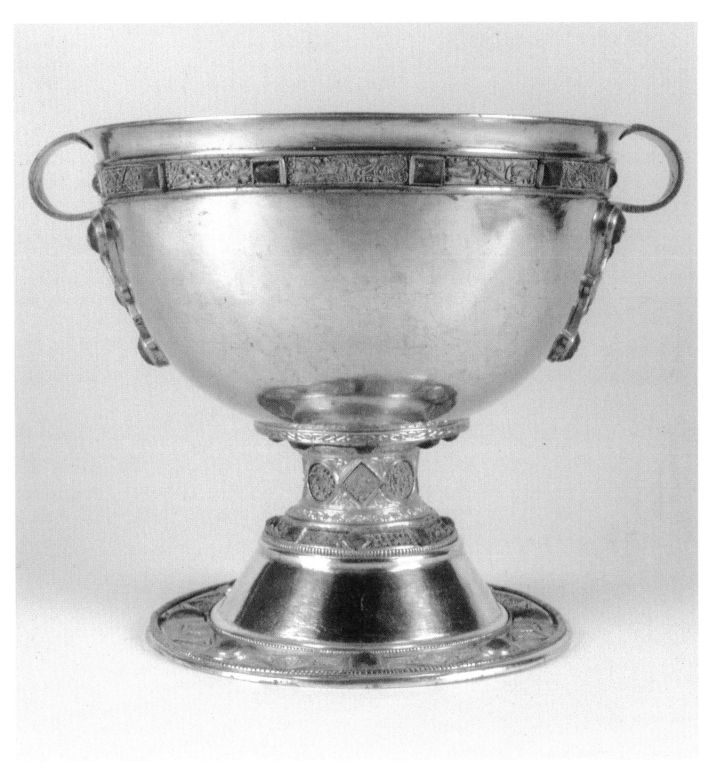

British example, owing to the fact that a number of Pictish animal images adorn the metalwork.

It is also associated however, with St Columba, the founder of the Iona monastery. Viking invaders seemed particularly fond of these reliquaries and many have been discovered in Norwegian graves having been transported there from Ireland.

The ministerial chalice of Derrynaflan is a later, less elaborate piece than the Ardagh chalice discovered on an old monastery site in Co. Tipperary (National Museum of Ireland, Dublin).

The diverse strands of Golden Age Celtic art eventually fused to produce one magnificent, monumental work at the end of the eighth century which many see as the climax of Celtic artistic tradition before the Viking impact. The *Book of Kells*, the most accomplished of all the illuminated manuscripts, is a concentration of ripened skill, drawing on the many and varied fields of experience of the Celtic artist. The Book is one of Ireland's greatest treasures, its three hundred and forty leaves, in all their stunning wealth of colour and intricacy, are today in the proud possession of Trinity College, Dublin. Here they are displayed alongside the *Book of Durrow*, the *Book of Dimma* and the *Book of Mulling*.

It is very likely that the *Book of Kells* was originally inspired by Saint Columba of Iona who had built up a tradition among the monks of his community of copying the Gospels on to parchment. His express wish was that each of his monasteries contain a Gospel Book worthy of Divine approbation. His followers were expected to achieve the highest standards in scriptoria and ornamentation. The *Book of Kells* is strong and original in design and adheres to the dictum of the Saint. Most scholars agree that it was produced in Iona after Columba's death, but there are others who argue that it is a Pictish manuscript dating from the late eighth century. The Book undoubtedly owes a certain amount to Pictish art, parts of its decoration mirror animal designs, often with a hunting or processional theme, carved on Pictish stone slabs in Scotland. These slabs, like the *Book of Kells*, date from the eighth or ninth century. More recent theories travel further in suggesting that it is an even later work, created no earlier than the second quarter of the ninth century.

Nobody can establish precisely when the Book was begun or how long the work was in progress. The main body of scholarly opinion adheres to the view that the manuscript, begun in Iona, subsequently came to Ireland shortly before AD 800 and was worked on there at the Columban monastery of Kells. This theory is substantiated by the fact that Viking raids, which began on the monasteries towards the end of the eighth century, drove many monks out of Britain and back to Ireland. In the year 806 it is recorded that the Abbot of Iona fled from such Viking attacks and took refuge in the Abbey at Kells, Co. Meath.

The Latin calligraphy of the *Book of Kells* is in a fine, bold hand, executed on calfskin pages of approximately thirteen by nine and a half inches. Although letters are generally well-rounded and consistently clear throughout the entire manuscript, there are signs of varying styles. Evidence points to a team of artists and scribes at work, perhaps half a dozen or more, each displaying his own individual style. Françoise Henry, the Celtic scholar previously mentioned, has estimated that the whole project may have taken up

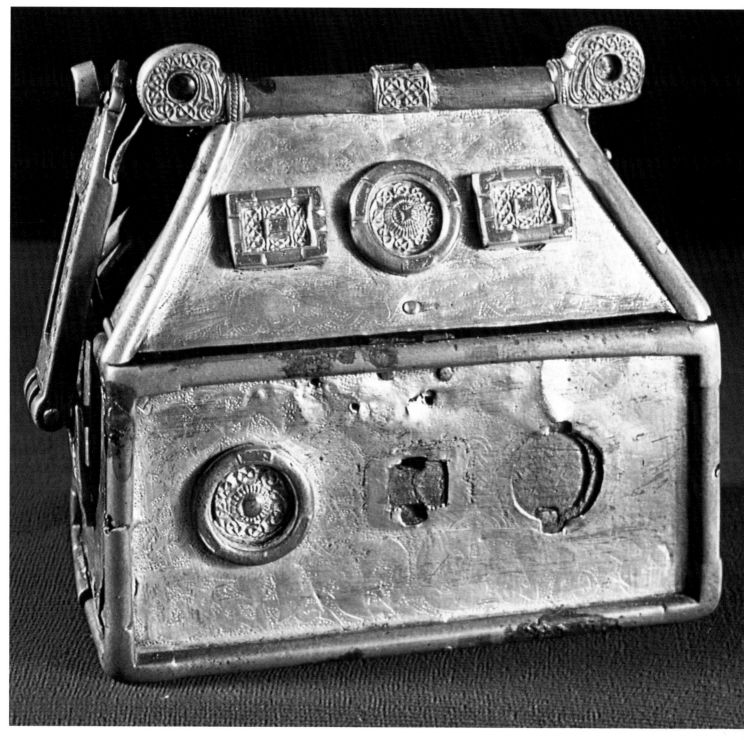

to thirty years to complete. Every single page has some sort of decoration; sometimes they become major illuminations, at other times the decorations remain small and uncomplicated, or small and incredibly complex. Parts of the manuscript require magnification in order to appreciate fully the very fine detail of the ornamentation. The artist's preference is for a colourful visual perfection rather than formal transcription.

Because they housed the relics of the saints, many reliquaries were thought to have miraculous powers. The Monymusk reliquary was taken into battle at Bannockburn in 1314 in a bid to protect the fighting army (National Museum of Antiquities, Scotland).

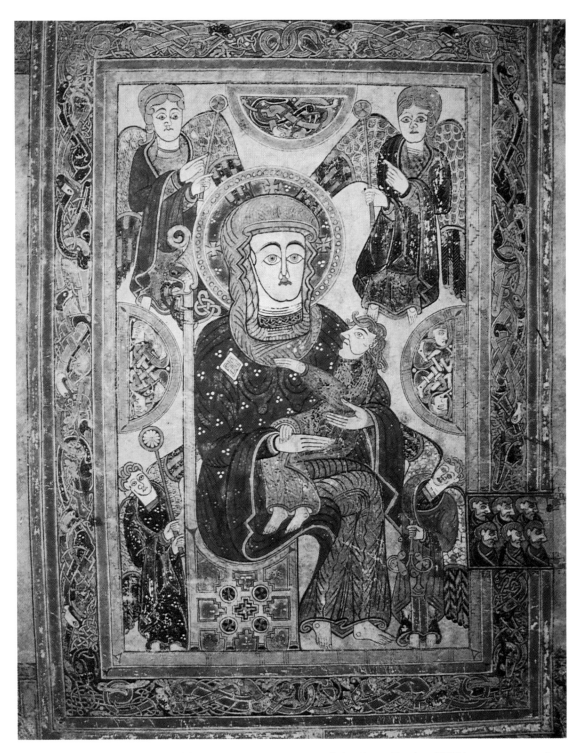

A twelfth-century account of the lost *Book of Kildare* manuscript, written by the Norman Welshman, Gerald, may be applied to the *Book of Kells*:

> *... if you take the trouble to look very closely, and penetrate with your eyes to the secrets of the artistry, you will notice such intricacies, so delicate and subtle, so close together and well knitted,*

so involved and bound together, and so fresh still in their colourings
that you will not hesitate to declare that all these things must have
been the result of the work, not of men, but of angels.

The opening page of each New Testament Gospel is intricately designed throughout the Book, and the beginning of each paragraph is clearly defined by an ornate initial, ingeniously decorated, often in the shape of an animal or some exotic plant. The use and range of colours is highly sophisticated. Shades of mauve, yellow, brown, bright blue, and green appear in the text. A vivid red colour appears frequently; the blue pigment must have come from Asia Minor, while the green was derived from Mediterranean vegetable leaves. The atmosphere is by turns eccentric and lively, humorous and solemn. Letters come alive on the page as a result of the scribes' remarkable talents. No manuscript before has exhibited such a wealth of amusing detail.

The life of Christ is the focus of the book; the central element, unlike earlier manuscripts, is man. The broad range of decoration and ornament, including spirals, interlacings, scrolls and foliage patterns, function to embellish the central human figure. Some of the outstanding pages include The Temptation of Christ, The Betrayal at Gethsemane and the Virgin and Child illustrations. In addition, there are Evangelist symbols, carpet pages, canon tables, miniature drawings between the lines of scripture, pages of ornamental initials and lively farmyard drawings. The Beatitudes in St Matthew's Gospel feature eight beautifully ornamented capital Bs, some in the shape of serpents, some with human heads, others with the heads of birds, all elaborately coloured. The *Chi-Rho* page, (symbol of Christ XPI) is quite unique in its design and innovation. The pigment 'orpiment' is used to produce a luxurious gold-leaf effect. A whole host of God's creatures decorate the surface of the page, humans, wildlife, domestic animals, insects, cats chasing mice, all joyfully announcing the birth of Christ.

The *Book of Kells* has had an adventurous life. It is now in an incomplete state; there is no beginning, no ending, no colophon, no closing prayer or signature. According to a report recorded in the *Annals of Ulster*, the Book was stolen in 1007 from the sacristy at Kells. At this time, it would appear that the manuscript had an ornamental cover. The Gospel was found after three months, the leaves still intact, but the golden cover was never recovered. At the time of the Reformation it passed to the British crown, but eventually it fell into the hands of Bishop Henry Jones of Meath, who presented it to Trinity College in 1661.

The wealthy monasteries were plundered by the Vikings during the ninth and tenth centuries and many of their treasures destroyed. The tradition of manuscript illumination degenerated rapidly as a result. The *Book of Kells* has no real competition among the manuscripts

One of the most popular pages of the *Book of Kells* – the Virgin and Child portrait (Trinity College, Dublin).

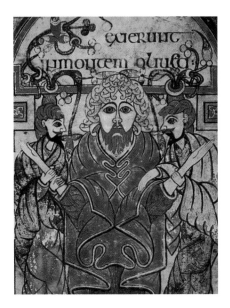

A full-page illustration depicting the Arrest of Christ, taken from the first Evangelist Gospel of St Matthew (Trinity College, Dublin).

Opposite:
The opening words of St Matthew's Gospel decorated with illuminated initials (Trinity College, Dublin).

produced after the ninth century. In Scotland, The *Book of Deer*, written in the tenth century, is reminiscent of the basic 'pocket Gospels'. The more famous *Book of Armagh*, produced in AD 807, is also a poor comparison and looks very plain as it lies on display next to the *Book of Kells* at Trinity College. It is an important historical manuscript, nonetheless, documenting the rise of Christianity and providing an understanding of the Irish Church's early history. The variations in the script point to two or more hands at work; illumination is scarce and the use of colour restrained.

The Vikings came to Ireland and England from the valleys and fjords of Norway. They were a pagan race, skilled in many crafts, particularly carpentry, and they possessed a keen eye for business and trade. The first settlers who colonized the islands of Shetland and Orkney were a peaceful people living a simple rural existence. With the building of seaworthy Viking ships and the introduction of sails, Norsemen travelled in larger, more organized groups not only to Ireland and England but also to Iceland, Greenland, Scotland and some parts of North America. The earliest recorded attack on Britain is written down in the Anglo-Saxon Chronicle for the year AD 787. In AD 793, the monastery of Lindisfarne was sacked. Scotland was plundered towards the beginning of the ninth century, including the monastery at Iona. The first Viking fleets appear to have arrived in Ireland in 837 and the Norsemen began to set up permanent bases. The building of towns began for the first time, wooden houses were erected and the whole face of Irish society underwent a dramatic change.

For the first forty years of Viking settlement in Ireland from 875 to 915, there was relative peace, but a century of destruction and pillage followed, ending in the Battle of Brian Boru at Clontarf in 1014. Ireland had no one central seat of power. As a consequence of this, the defence of the island as a whole was difficult to maintain. Monks fled the monasteries of Clonmacnoise and Armagh, having suffered a series of attacks by Norse invaders. Monasteries arranged for many of their illuminated books and treasures to be carried abroad for safe-keeping. Irish manuscripts at St Gall and other places on the Continent testify to the movement of valuables out of Ireland during these centuries of Viking wars. Numerous metal objects manufactured in Ireland, Scotland and Northumbria have been discovered in Scandinavian graves.

The Norsemen produced very little of their own art, but they did influence the development of Celtic art from the beginning of the ninth through to the twelfth century. A vigorous tradition of stone carving evolved to replace intricate metalwork and the illumination of manuscripts. It may well be the case that Celtic artists considered stone to be the only medium which would survive widespread Viking desecration. Stone carving quickly made the transition from

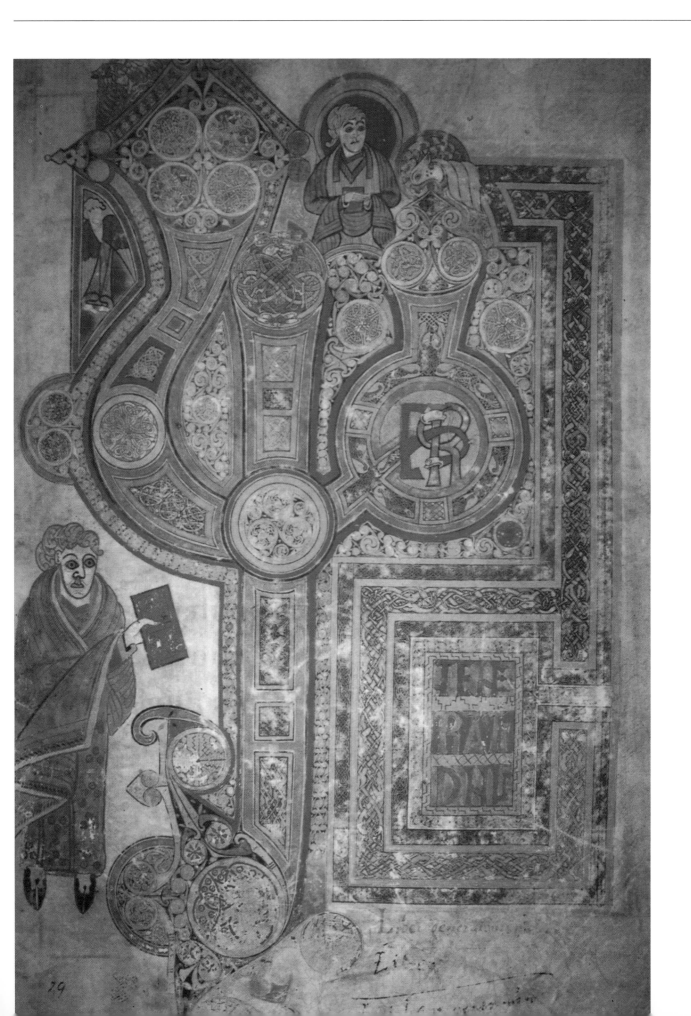

The High Crosses became especially fashionable in Ireland following the Viking invasion. The cross at Moone, Co. Kildare, is an unsophisticated, yet striking, example of the Celtic craftsman's conversion to stone sculpture (National Museum of Ireland, Dublin).

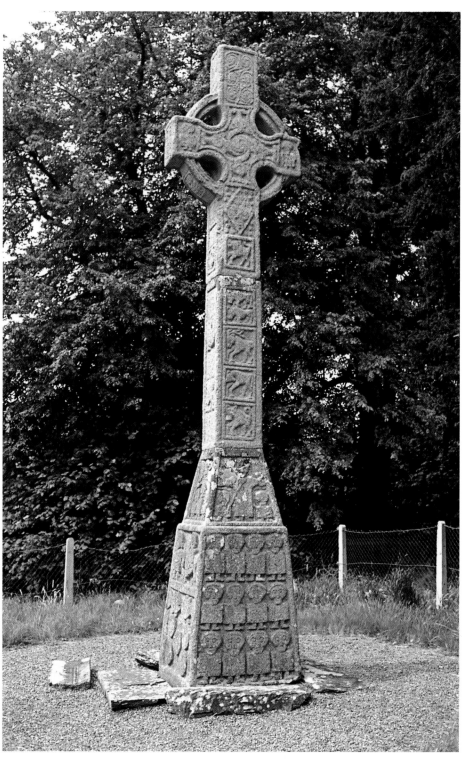

cross-inscribed slab to high cross proper. The first free-standing, ringed crosses appeared in the eighth century in Ireland and represented this whole new aspect of Irish art. They proved unpopular in Scotland, however.

Very early free-standing crosses had pleasant, simple designs and many were engraved with the names of the Christian dead.

High Crosses, on the other hand, lost their funereal character, biblical scenes were introduced and were featured more and more prominently, figured scenes began to appear on the panels until eventually, in some cases, single figures dominated, usually of Christ or a revered bishop, in high relief on the upper portion of the cross. Ultimately, the sculptor sought to reflect in stone the magnificence of jewelled metalwork.

Although they belong to the pre-Viking era, the two High Crosses at Ahenny, Co. Tipperary, are truly distinctive early crosses and point to the way forward in High Cross design. Although they are carved in stone, both appear to imitate wooden crosses decorated by metal plates. The cable pattern around the edges of the crosses is definitely inspired by eighth-century metalwork. The high relief bosses imitate enamelled studs. The crosses exhibit fine interlace and deeply carved spirals and represent a considerable development of the earliest designs of High Crosses on the island of Iona. Biblical scenes, now weathered away, but possibly depicting Noah's Ark and the Lion's Den, were an innovative element appearing on the base of the cross. The introduction of figured scenes was probably inspired by French Carolingian art admired by missionary monks on the Continent. Gradually Old Testament figure carving began to replace more abstract designs.

Most of the splendid Irish High Crosses belong to the ninth and tenth centuries. More elaborate iconography and scriptural scenes began to appear. The cross from Moone, Co. Kildare, is slim, tall and elegant and exudes a charming simplicity. It is carved from granite, whereas most other crosses are carved in sandstone. Its graceful frame is decorated by a number of spectacular panels. One such panel on the pyramid-shaped base of the cross depicts the twelve Apostles gathered in groups of four. The figures are strictly stylized with square bodies and anxious, peering faces. Old and New Testament subjects appear in other panels on the four sides of the cross, including the Flight into Egypt, the Sacrifice of Isaac and the Crucifixion.

The Cross of Muiredach at Monasterboice is a very fine example of this later period of Celtic art and there is nothing in Europe at the time to compare with it. Dated by its inscription to AD 923, it stands eighteen feet high and is carved of sandstone. Both faces of the cross reveal figure carving, not unlike that of the St John's Crucifixion Plaque. The east face depicts the crucifixion of Christ surrounded by the lance and sponge bearers and a group of angels. The west face portrays the last Judgement Day, with Christ separating the good people from the evil, indicating the way to either Heaven or Hell. In spite of the fact that it is carved of sandstone and must have been subjected to harsh weather conditions over the centuries, the detail on the Monasterboice cross is still very clear.

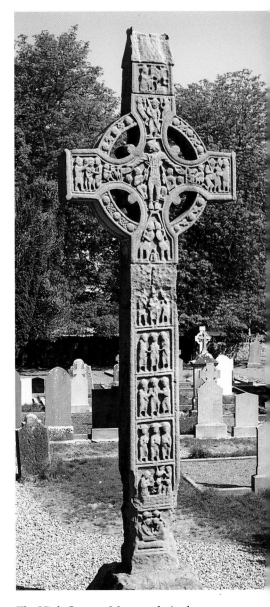

The High Cross at Monasterboice has no equal in Europe and is a finely preserved monument of Irish Viking stone sculpture. The mingling of scriptural scenes with abstract patterns reaches a perfect balance in this piece (National Museum of Ireland, Dublin).

Much of the Celtic metalwork surviving from the ninth and tenth centuries in Ireland is fairly coarse. Metalwork seems to have deteriorated in quality over this period to experience a new lease of life in the eleventh century. A series of Scandinavian styles increasingly manifest themselves in metal designs. Jellinge style emerged in the late ninth century and is named after the royal seat at Jellinge in Jutland, Denmark. It is characterized by animal motifs drawn with double outlines and pigtails. The later Ringerike style which developed in the early eleventh century combines animal motifs with foliage ornamentation. A final style of Urnes ornament, introduced around 1050, was named after a wooden church in Norway and is typified by new foliage patterns of elongated tendrils carved on the metalwork.

Annular brooches, like the Tara brooch, survived the Viking incursion and were produced well into the ninth century. The new form of hybrid Irish-Norse art focused considerably less on minute detail. Enamelling was no longer a popular feature and filigree work was unsophisticated. Large areas of the brooches remained undecorated and they reveal little of the splendour of earlier pseudo-penannulars. During the ninth and tenth centuries the production of crosiers became increasingly common. The manufacture of reliquaries for these, and also for bells and books, occupied the majority of the metal craftsman's time. The best early examples of crosiers include the Kells crosier, and the crosiers of St Dympna and St Mel. Panels on the crooks of these ornamented staffs were made of hammered precious metals and were lavishly decorated with animal ornament or complex interlace.

Monasteries at this time, were experiencing a temporary resurgence of power and many had metal workshops attached to them. The shrine for the *Cathach* was produced at the end of the eleventh century. The Saint Patrick's Bell Shrine was made around the year 1100. It was created by order of the King of Ireland and was used to enshrine a relic of Saint Patrick, in this case a bell, believed to belong to the saint. The shrine is made of bronze and decorated with elaborate filigree. Gold and silver interlace designs develop into animal shapes, evidently influenced by the Scandinavian Urnes style. The Lismore crosier dates from the same time and was presented to the Bishop of Lismore in County Waterford in the early twelfth century. The crosier is an impressive piece representing a return to more elaborate ornamentation. The bronze crook, shaped rather like a seahorse, probably once held gold filigree work. The glass *millefiori* studs on the shaft have survived, complete with cross designs, and it appears that the crosier was heavily gilded at one point.

The presence of so many examples of this form of ecclesiastical object in Ireland from the ninth to the twelfth centuries reflects the

The St Patrick's Bell Shrine was probably made in Armagh some time between 1091 and 1105. It is clearly influenced by Scandinavian designs but they are executed by the Irish craftsmen with skill and discipline (National Museum of Ireland, Dublin).

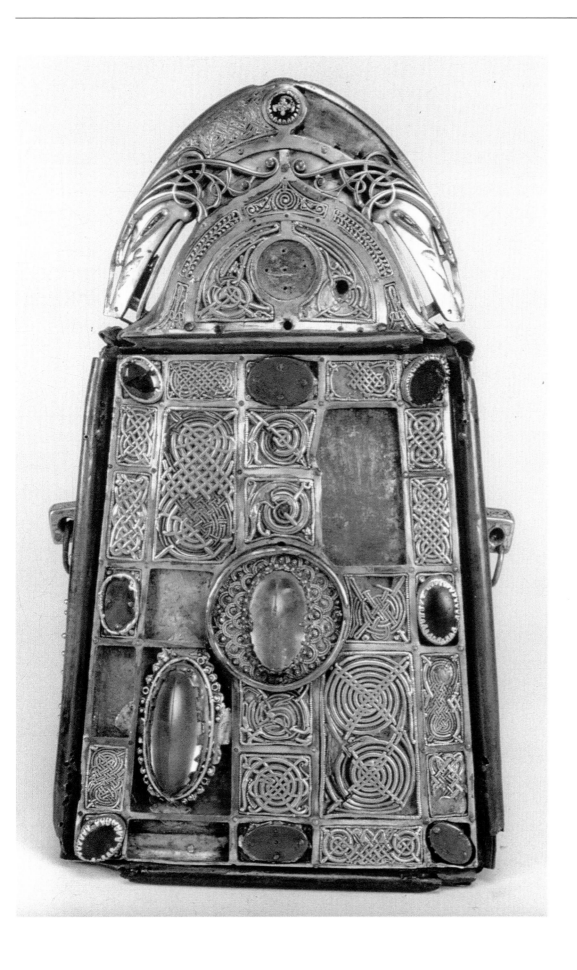

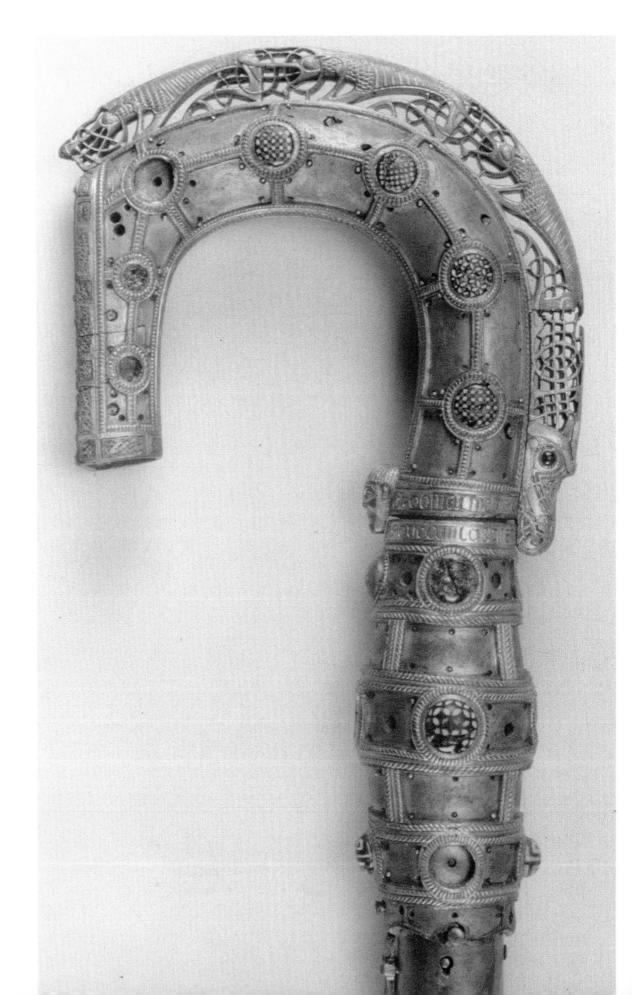

growing pressure on the Irish church to conform to more formal Episcopal patterns of administration which were well-established throughout Christianized Europe. Ultimately, the monastic enclosures succumbed to this pressure, becoming absorbed in diocesan structures, surrendering their powers of insular artistic expression in favour of a more uniform existence. By 1142, a Continental order of Cistercian monks had arrived in Ireland, eventually challenging the control of the old Irish monasteries. A unique world of Irish art was nearing the end of its natural life.

The Cross of Cong represents perhaps the last great flourishing of Celtic religious art. It is a large, rather beautiful processional cross, echoing some of the best qualities of eighth-century Celtic metalwork. It was created at the request of the King of Connacht, Turlough O'Connor, in the year AD 1123. The cross is made of oak encased in sheets of copper and silver riveted together. A large rock crystal at the centre of the cross protects a fragment of the True Cross, perhaps the most important relic of the Christian church. Small glass and enamel bosses are placed at strategic points between the filigree-decorated copper panels at the front of the cross. The sides, made of silver, are engraved with various inscriptions, one of which cites the name of Maelisu, as the artist who created the piece. The back of the cross is decorated with four slim panels of Urnes-style animal interlaces. A grotesque, menacing animal head adorns the base of the cross, grasping it in its teeth. The cross itself was not intended to be held by human hands and this head, sumptuously engraved with spirals and

Opposite:
The Lismore crosier is the most elaborate in a range of crosiers produced in Ireland from the ninth to the thirteenth centuries. The decorative knops are a special feature, embellished with panels of wiry gold filigree, glass studs in red, blue and white and intricate engraving (National Museum of Ireland, Dublin).

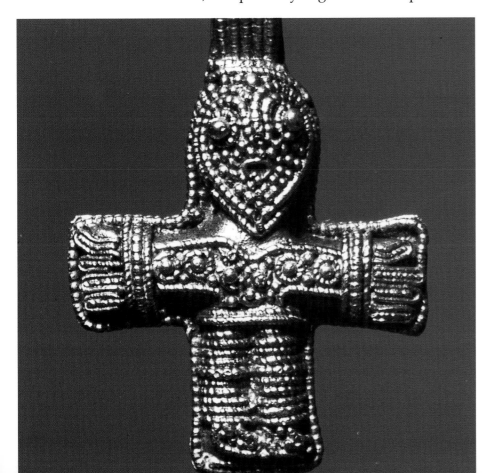

An example of a metalwork cross dating from the Viking era. This type of object reached a pinnacle of perfection in the Cross of Cong (National Antiquities Museum, Stockholm).

scale patterns forms a handle, guarding the cross against human contact.

The Battle of Clontarf is treated as the historical landmark of Viking retreat from Ireland. The triumph at Clontarf was a short-lived one, however. A systematically thorough conquest of Britain by the Normans occurred shortly after this victory in 1066. The subsequent Anglo-Norman invasion of Ireland in 1169 was perhaps the single most important event since the arrival of Christianity in Irish history, leading to dramatic changes in society. It signalled the final demise of Celtic Art and a Celtic way of life, as the country bowed to a ruthless policy of partition and subjugation. The creation of the Anglo-Irish Pale brought prolonged periods of war and imposed extensive cultural and political upheaval. By the thirteenth century, Celtic civilization had been absorbed into a mainstream European structure.

Celtic-style art re-emerged with renewed vigour in Ireland in the nineteenth century, its resurgence inspired by the desire to redress a situation of ongoing deprivation far in excess of anything Ireland had ever suffered before. Today, its many diverse reincarnations act as powerful symbols of Ireland's pride in her national identity.

The Cross of Cong is arguably the finest achievement in Irish metalwork to emerge in the final years of Celtic art, towards the middle of the twelfth century. The animal ornament on the piece is the most perfect version in Irish art of the Urnes style (National Museum of Ireland, Dublin).

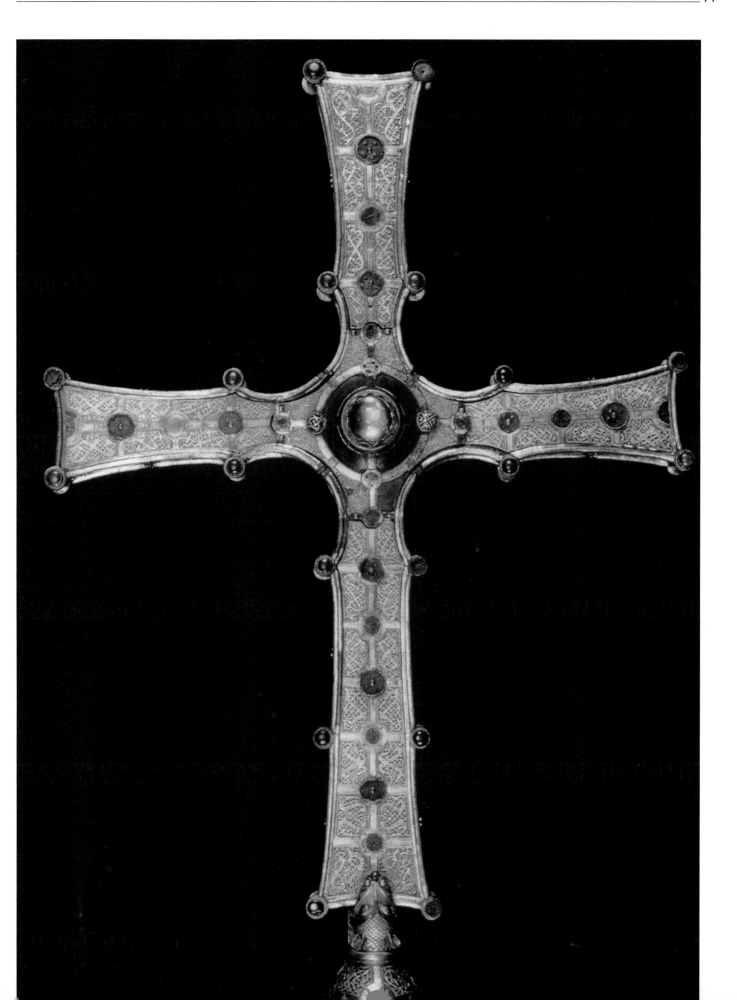

GLOSSARY

Abstract: In art terms, this describes an approach which is non-representational, i.e., *non-naturalistic*, see below.

Antiquity/Antique: The term used to describe Greek and Roman civilization until the fall of the Roman Empire in the fifth century AD.

Carolingian: The name given to describe the dynasty of French kings founded by Charlemange.

Curvilinear: A pattern formed of curved lines.

Enamel: This technique was not in existence before the fourth century BC and was popularized by the Romans. It involved the riveting of red glass studs, imitating the more expensive coral studs, on to many objects. Pieces of glass were softened by heat, then shaped, and either set in cells or fastened to the keyed base-plate with pins. Enamelling reached a peak in Ireland and Britain towards the end of the first century.

Filigree: The use of gold or silver wire, first polished or twisted, as a decorative device. The braids were soldered on to the metal object; the technique is particularly apparent in Anglo-Saxon metalwork.

Granulation: The Tara brooch is a good example of granulation. It involved minute drops of gold being dropped on to the surface of the ornament, usually jewellery, which were then soldered on to the surface of the object.

Gilding: The art of applying gold, which has been beaten into paper-thin leaves.

Illumination: This practice involved the ornamentation of initial letters and is characteristic of the many Christian manuscripts which were produced in Ireland and Britain after the fifth century AD. Initials were decorated with spirals, palmettes and bird-like scrolls,

Interlace: A frequent motif of La Tène art prior to the fifth century BC, and found on many of the Celtic *Waldalgesheim* objects. The pattern was inspired by foliage designs of Greek origin, always following a curvilinear form.

La Tène: The term was originally used to describe the art of the Celts, discovered at Lake Neuchâtel in Switzerland. It is now commonly used to describe the Iron Age art in Europe up to the point of Roman occupation.

Millefiori: This form of glass was made by drawing out thin rods of different coloured glass, fusing them together and then slicing them to produce a multi-coloured patterned glass. Studs of this glass were used for intricate and minute designs in metalwork.

Naturalism: The accurate representation of objects and scenes as they appear in nature.

Palmette: A classical style of ornament resembling a palm leaf.

Penannular: Brooches of this type, in the form of a complete circle, except for one break, were very popular in Roman Britain and were developed from simple ring brooches.

Peltas: The Mediterranean version of the early Celtic palmette looking a bit like a mushroom with thin stem and curling cap.

Plastic Style: The art of carving, modelling or moulding, with a view to producing a three-dimensional effect. The term is often used to describe La Tène art executed in relief, dating to the third century BC.

Pictland/Picts: A pre-Celtic population living in Scotland, north of the old Antoinine wall, who survived the Romanizing of Britain; also known as the 'painted people'. Many characteristics of their art were combined with the art of the Celts.

Relic: In Christian circles, a relic is a preserved object once associated with a saint. It was often a tiny piece of the saint's body; for example, a piece of bone.

Relief: Artwork which projects outwards from its surface. Relief can be low or high.

Repoussé: A relief or embossed effect produced by hammering the metal from behind.

Scrolls: A spiral ornament frequently used in La Tène art.

Stylized: Images which are simplified and repeated in a similar way; for example, the bodies and faces in early Irish manuscripts are stylized. Eyes, hair, mouths, etc. are treated in a similar way by all artists, rather than attempting to represent individual features.

Tendril: A slender, threadlike leaf or stem by which a plant anchors itself to a support.

Terminal: An ornamental carving at the end of an object.

Torque: Sometimes referred to as a neck ring. These personal ornaments were made of silver or gold and accompanied their owners to the grave.

Triskele: A symbol consisting of three bent legs or lines radiating from a centre.

Trumpet Scroll: A relief pattern of curves beginning as a thin line, then fanning out into a shape like a trumpet end.

Zoomorphic: Conceived as having an animal shape and therefore represented by animal motifs. In Celtic art the term is frequently used to describe the terminals of penannular and annular brooches.

INDEX

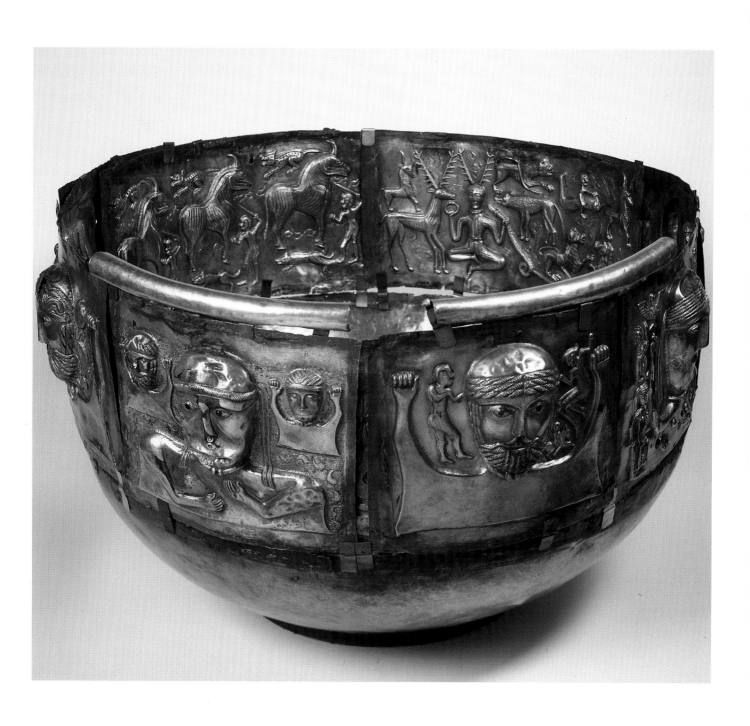

Celtic Art. Gundestrup cauldron
(Copenhagen, National Museum)

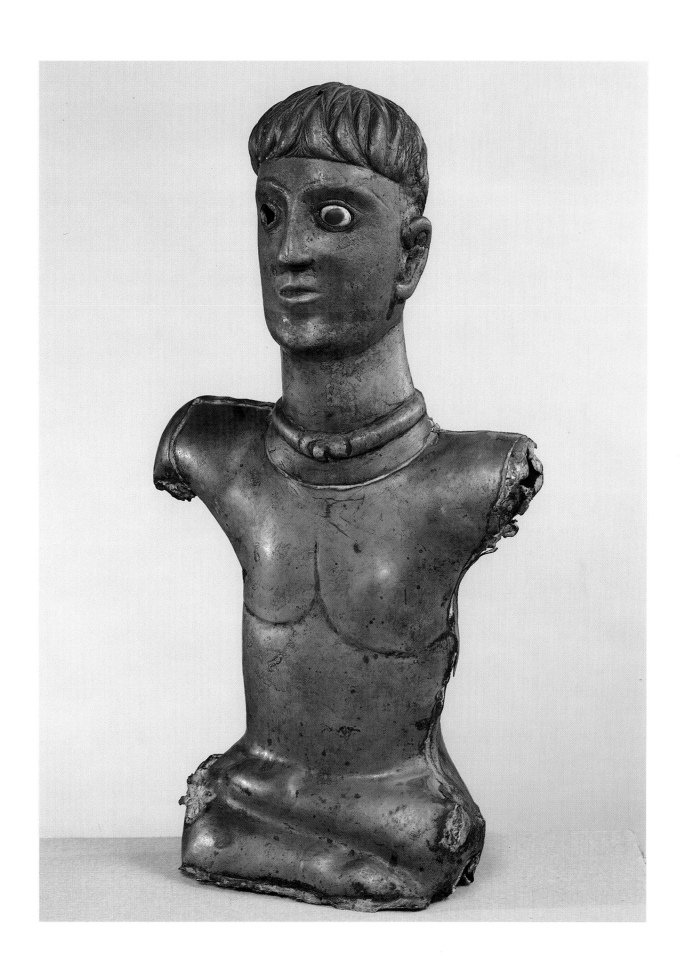

Celtic Art. Bronze figure with torque
(National Museum of Antiquities, St Germain-en-Laye)

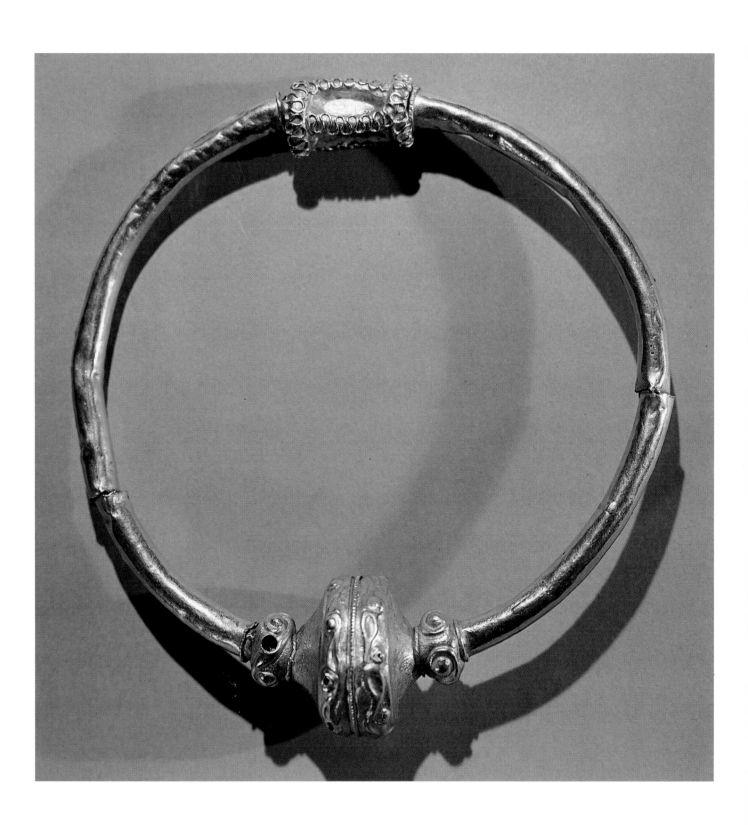

Celtic Art. The Clonmacnoise torque
(National Museum of Ireland, Dublin)

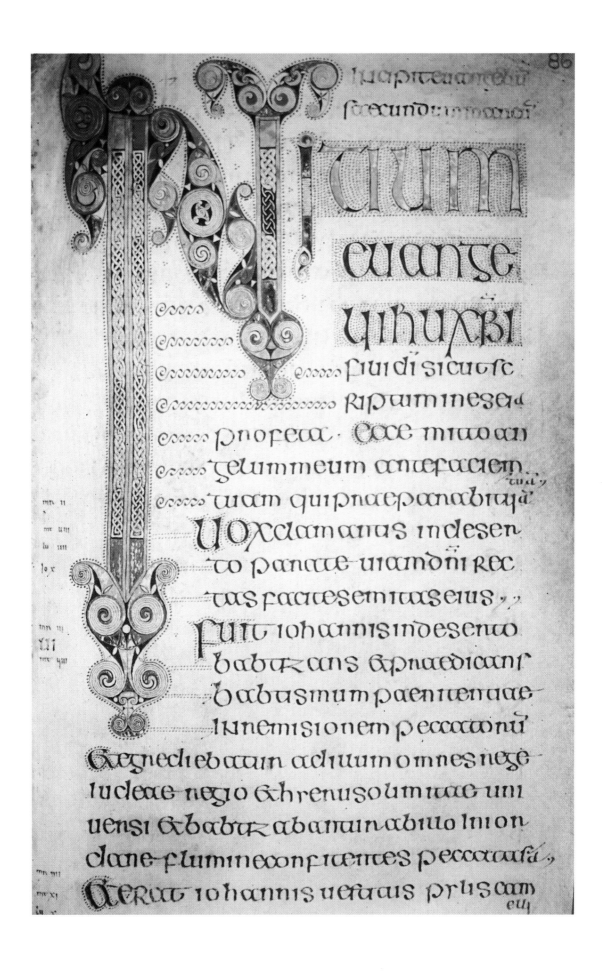

Celtic Art. Initial page of the Gospel of St Mark from the *Book of Durrow*
(Trinity College, Dublin)

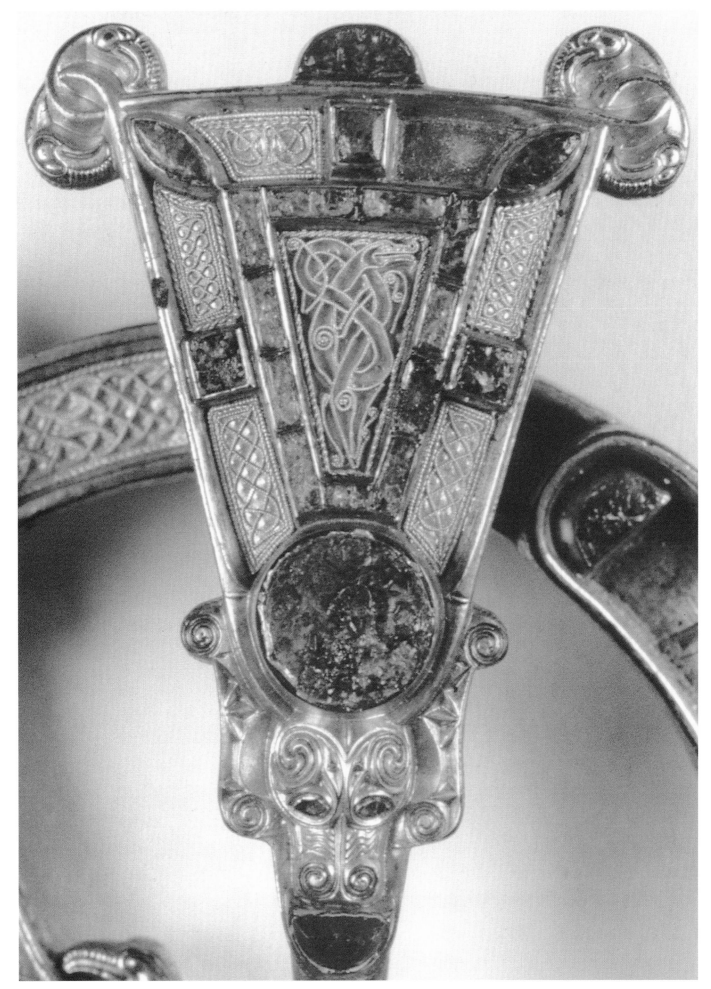

Celtic Art. The Tara brooch (detail)
(National Museum of Ireland, Dublin)

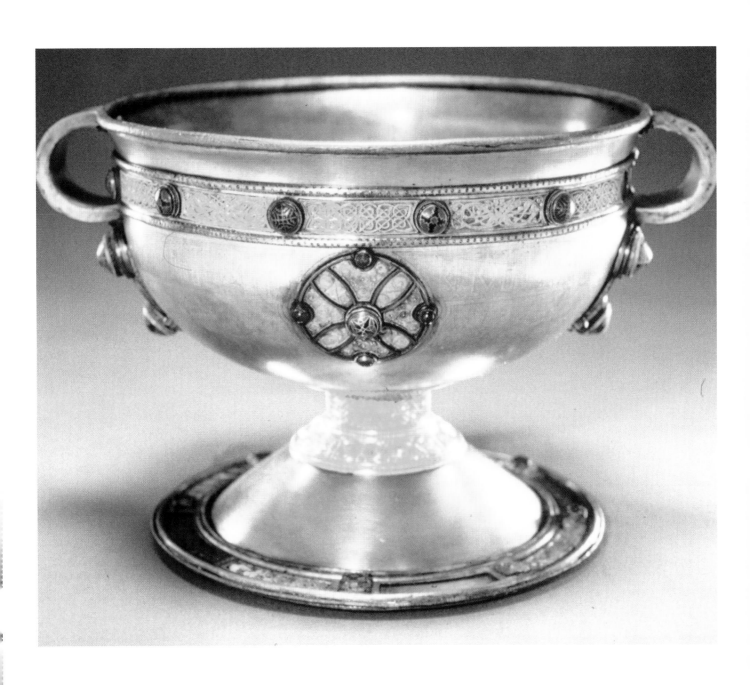

Celtic Art. The Ardagh chalice
(National Museum of Ireland, Dublin)

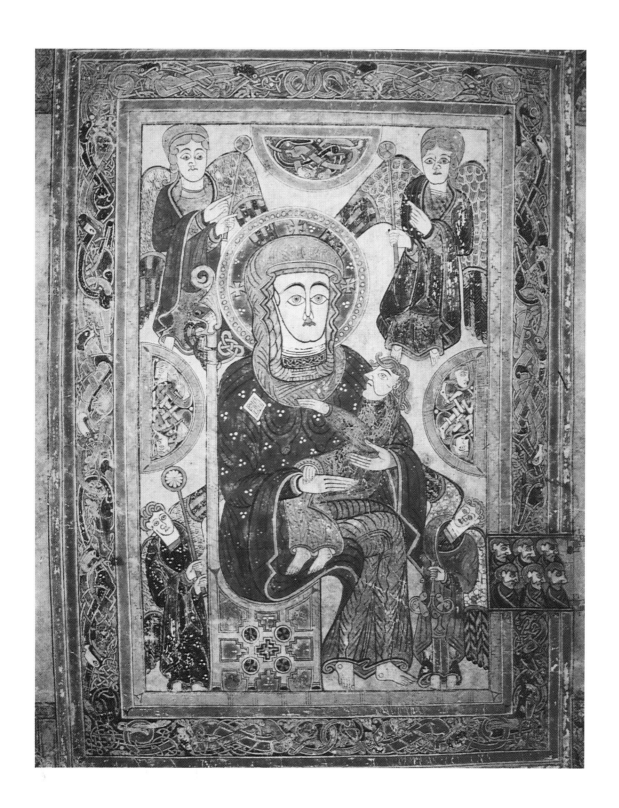

Celtic Art. Virgin and Child from the *Book of Kells*
(Trinity College, Dublin)

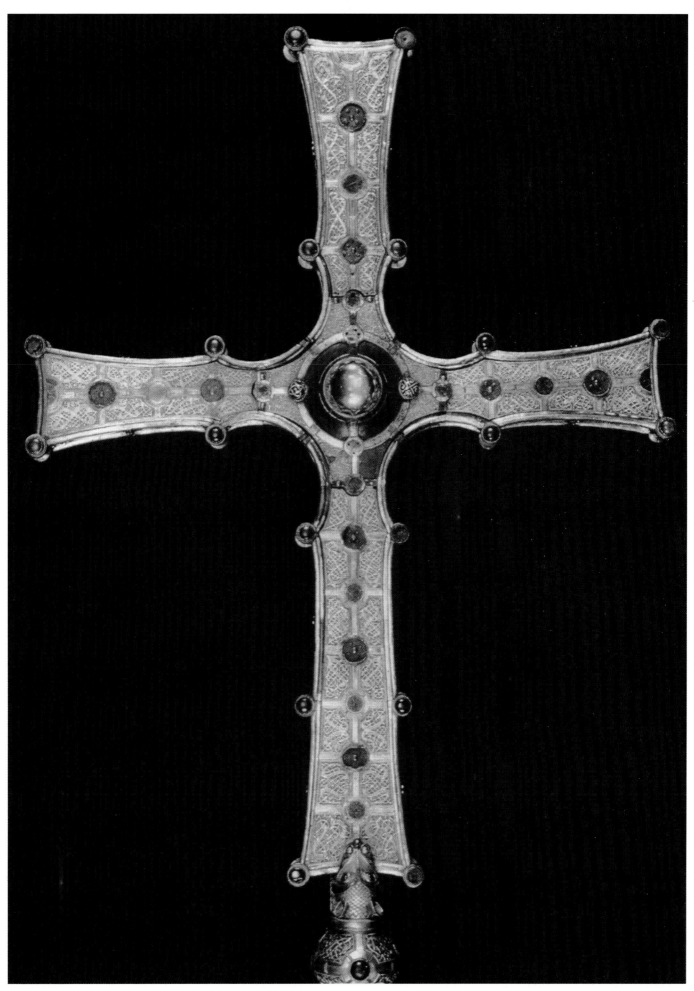

Celtic Art. The Cross of Cong
(National Museum of Ireland, Dublin)